AMPLIFIED ART

Dynamic Techniques for High-Impact Pages

Kass Hall

NORTH LIGHT BOOKS
CINCINNATI, OHIO
www.artistsnetwork.com

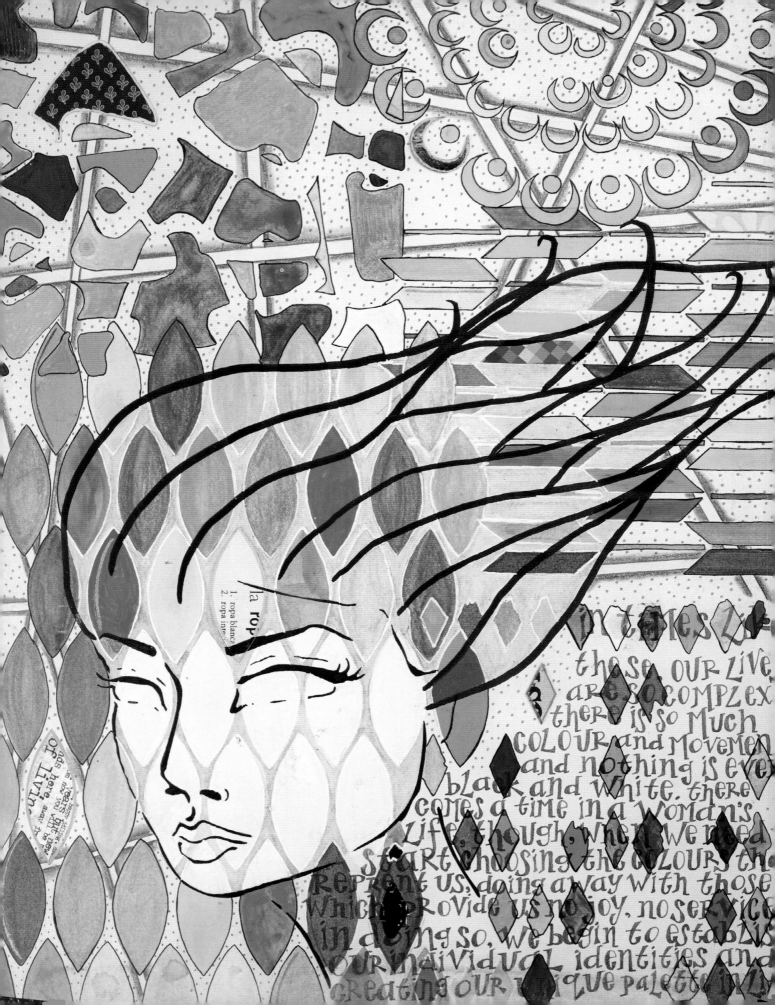

la rop
1. ropa blanca
2. ropa inte

Oh Living...

In times like those, our lives are so complex, there is so much colour and movement and nothing is ever black and white. There comes a time in a woman's life, though, when we need start choosing the colours that represent us, doing away with those which provide us no joy, no service. In doing so, we begin to establish our individual identities and creating our unique palette in life.

Contents

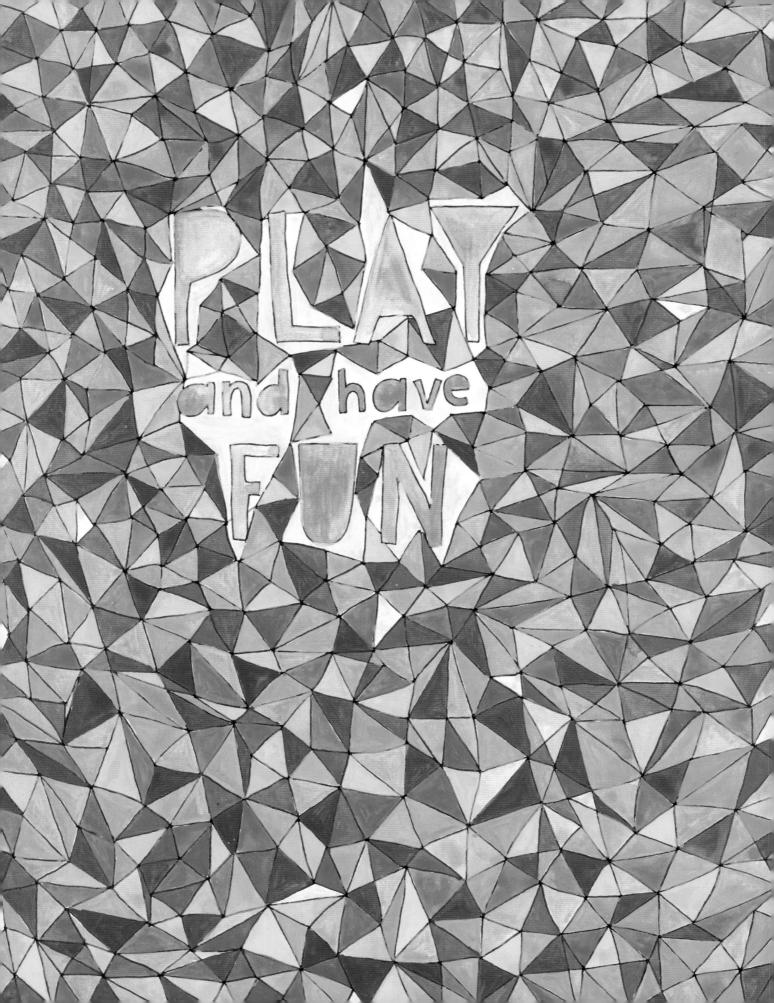

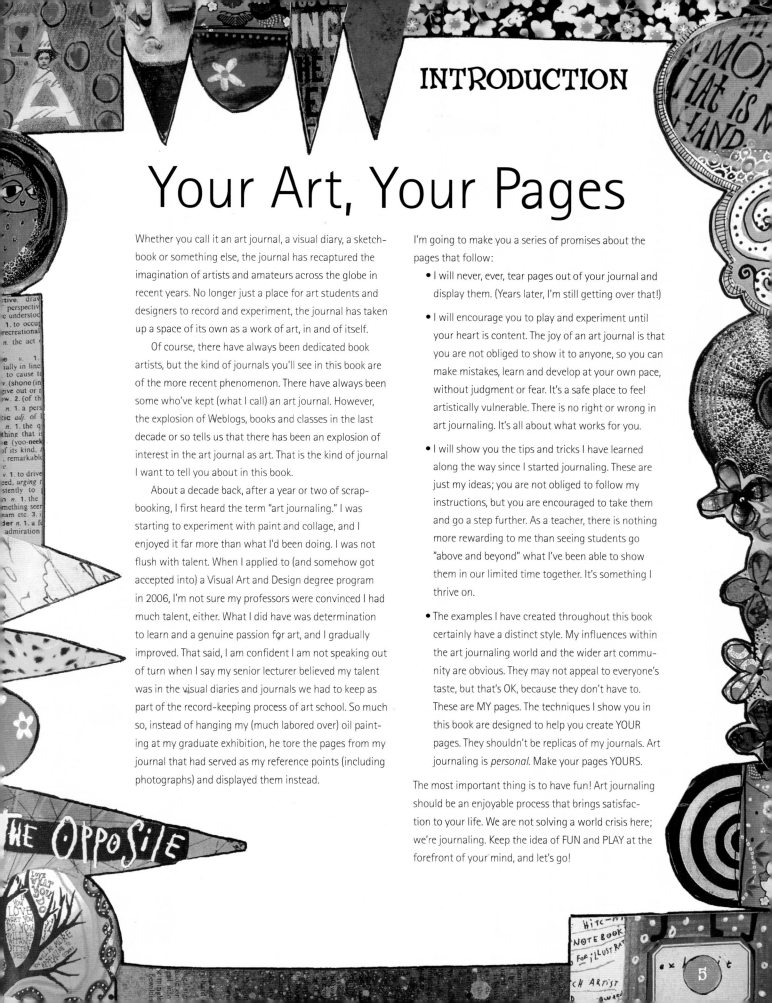

Your Art, Your Pages

Whether you call it an art journal, a visual diary, a sketchbook or something else, the journal has recaptured the imagination of artists and amateurs across the globe in recent years. No longer just a place for art students and designers to record and experiment, the journal has taken up a space of its own as a work of art, in and of itself.

Of course, there have always been dedicated book artists, but the kind of journals you'll see in this book are of the more recent phenomenon. There have always been some who've kept (what I call) an art journal. However, the explosion of Weblogs, books and classes in the last decade or so tells us that there has been an explosion of interest in the art journal as art. That is the kind of journal I want to tell you about in this book.

About a decade back, after a year or two of scrapbooking, I first heard the term "art journaling." I was starting to experiment with paint and collage, and I enjoyed it far more than what I'd been doing. I was not flush with talent. When I applied to (and somehow got accepted into) a Visual Art and Design degree program in 2006, I'm not sure my professors were convinced I had much talent, either. What I did have was determination to learn and a genuine passion for art, and I gradually improved. That said, I am confident I am not speaking out of turn when I say my senior lecturer believed my talent was in the visual diaries and journals we had to keep as part of the record-keeping process of art school. So much so, instead of hanging my (much labored over) oil painting at my graduate exhibition, he tore the pages from my journal that had served as my reference points (including photographs) and displayed them instead.

I'm going to make you a series of promises about the pages that follow:

- I will never, ever, tear pages out of your journal and display them. (Years later, I'm still getting over that!)

- I will encourage you to play and experiment until your heart is content. The joy of an art journal is that you are not obliged to show it to anyone, so you can make mistakes, learn and develop at your own pace, without judgment or fear. It's a safe place to feel artistically vulnerable. There is no right or wrong in art journaling. It's all about what works for you.

- I will show you the tips and tricks I have learned along the way since I started journaling. These are just my ideas; you are not obliged to follow my instructions, but you are encouraged to take them and go a step further. As a teacher, there is nothing more rewarding to me than seeing students go "above and beyond" what I've been able to show them in our limited time together. It's something I thrive on.

- The examples I have created throughout this book certainly have a distinct style. My influences within the art journaling world and the wider art community are obvious. They may not appeal to everyone's taste, but that's OK, because they don't have to. These are MY pages. The techniques I show you in this book are designed to help you create YOUR pages. They shouldn't be replicas of my journals. Art journaling is *personal*. Make your pages YOURS.

The most important thing is to have fun! Art journaling should be an enjoyable process that brings satisfaction to your life. We are not solving a world crisis here; we're journaling. Keep the idea of FUN and PLAY at the forefront of your mind, and let's go!

Materials

When teaching classes around the world, my most asked question is about art materials. What follows is what I tell my students.

- Playing and experimenting are the fun parts of having an art journal. Not every technique you try will work out, and not every material you try will suit your purposes. Don't be afraid to try new things and don't get hung up on having the "in product," especially in the early stages of your play.

- When starting out, buy just a few of any one material. A brand or product that is beloved by one artist may not be what you're looking for. Many times I have tried products on the recommendation of other artists and, although they were good-quality materials, I found they weren't for me.

 For example: acrylic paint. When I was traveling in the United States a few years ago, I bought little bottles of a popular acrylic paint brand because it was the "in thing." They are very expensive where I live, so I bought every color the store had—about forty-five bottles. Five years on, I still have many of them because I like my paints more opaque than these paints generally are. The take-home message is that had I bought half a dozen basics and played first, I'd have recognized that, while they are high-quality paints, they don't really suit my style of art journaling. Not to mention I'd have saved myself a couple hundred dollars. I have a strict philosophy of "use what you have" so I am slowly emptying those paints, but I won't buy them again and the lesson has stayed with me.

- A few good-quality basics are much more useful to you than a room full of supplies. Trust me: I have a room full of supplies yet I go to my core materials on every occasion. There are no hard-and-fast rules about what you must have. I've listed some things I think every art journalist will use and enjoy, but it's just my opinion. Play, experiment and test products out when you can. You'll soon start to get a feel for what works for you. It may not be what works for others.

- Buy the best you can afford. Good-quality paintbrushes, when looked after, are investments that pay for themselves. You don't have to have the best of everything, but a few of the better products are going to be more effective than heaps of crappy stuff. You'll feel better about your work if you are invested in it—emotionally and, to some extent, financially. You don't have to spend a lot, just invest wisely.

- Look at labels. If there is a water-based or nontoxic option, take that option. Oil-based products often leave an oil ring when used in journals. If a product has health warnings on it, the choice is yours, but ask yourself if an art journal is worth the risk to your health. I personally think the answer is no.

My Essential Art-Journaling Kit

- A **good-quality art journal**. I choose the Strathmore Mixed Media journals because they lie flat, the paper quality takes plenty of wet media and the pages don't buckle. Buy the best you can afford.

- A basic set of **fluid or soft body acrylics**: blue, red, yellow, green, black and white. These dry faster and flatter than heavy body acrylics and are easier to write over later.

- A **black and a white gel pen**. The debate rages on about which brand is best—always a personal choice. I love the uni-ball Signo or Sakura Gelly Roll. Colored gel pens are brilliant for adding details.

- A basic set of **colored pencils**. Derwent Inktense can be used both wet and dry. Prismacolor pencils go over almost anything. A basic set of twelve gets you started.

- **Acrylic paint markers** are fantastic. Sharpie Extra-Fine-Point black and white markers are what I do most of my lettering in, as well as edging and details. Grab some colored ones, too if you can. You'll wonder how you managed without them.

- **Baby wipes**. Never leave home without them.

Not essential but always useful:

- Some **stencils.**

- Some **watercolors**. Peerless makes some that are easy and lightweight and take up no room.

- A **waterbrush** for watercolors, but you can use them to make acrylic washes, too.

- **Mark-making tools**. Punchinella, Bubble Wrap and other things that can make marks.

- **Washi tape**.

- **Rubber stamps** and a waterproof ink pad.

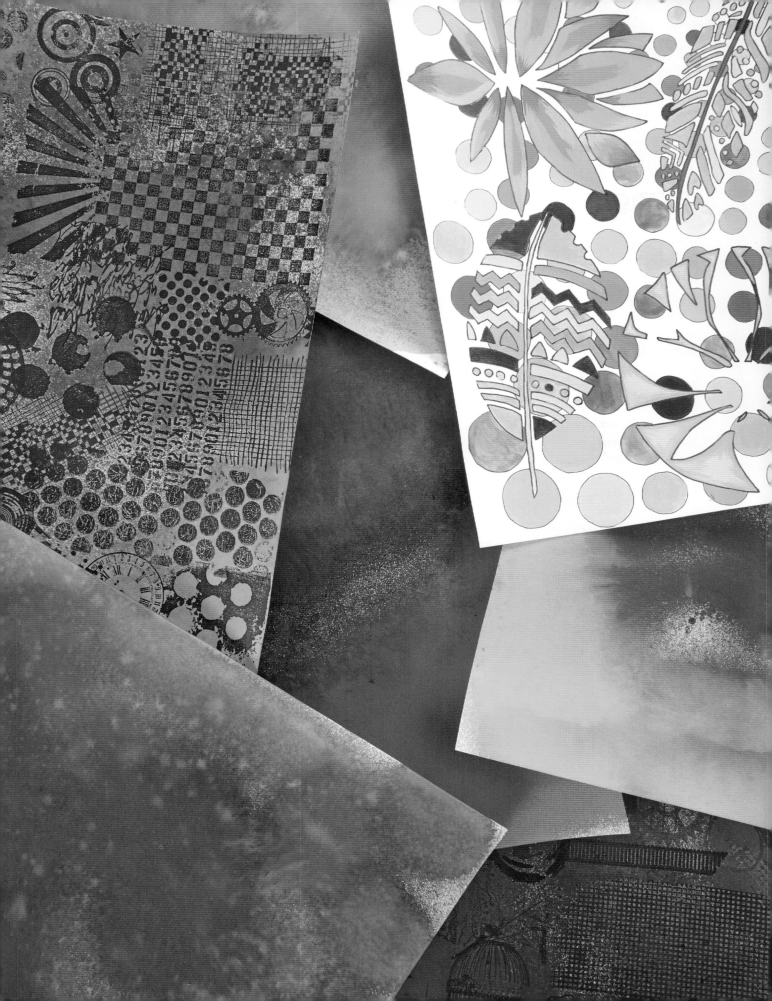

Making Your Own Collage Papers

Using collage is an incredibly popular and easy way to include imagery in your journals. You can find images in magazines and online and save them for printing. Keep in mind that copyright applies, which means if you want to sell or publish your work, you need to find a new way to include collage in your journals. You might alter what you find so drastically that it's unrecognizable, but this can take time and still treads a fine line. One solution to this is to start making your own collage papers.

One way to do this is to scan your own journal pages and then crop sections of those (á la Teesha Moore), and that is a great strategy. If you don't have a scanner, there are now several smartphone apps just for this (I use Scannable). Designing your own collage sheets is not only a lot of fun, but it also means you'll never run into those pesky copyright issues. You'll see some of these ideas in the following pages. Hopefully, you will be inspired with some ideas of your own.

Having your own laser printer is useful for these exercises, but it is not essential. You can always take what you create and have it copied at your local copy center; it shouldn't be expensive. Have your pages printed on slightly heavier paper—around 120gsm/80-lb. is great. Printing on an ink-jet means the ink is not waterproof, so you either need to buy a waterproofing spray or refrain from using any wet media over the printing (so no paint!). It's all a little harder than it needs to be, which is why I recommend laser printing. (Of course, you might like ink smudges. In that case, print away!)

If you are savvy with programs like Adobe Photoshop or Illustrator, the opportunities open to you are endless and go far beyond what I'll show you here. If you're not, don't panic, you needn't be.

As always, if you don't have something listed on the Materials to Gather list, just use what you have. As you work through these exercises, you'll start to have ideas of your own and see things you *do* have on hand that might be useful. There are no rules here!

Materials to Gather

acrylic paint (your choice of colors)

colored pencils (your choice of colors)

craft knife

cutting mat

eraser (white)

glue or acrylic medium

ink pad, waterproof black

markers (your choice of colors)

patterned papers (scrapbooking papers, origami papers—anything you have will be perfect)

permanent markers, black (a couple different points)

rubber stamps

scissors (a sharp pair)

stencils (a variety of your choice)

white paper (I recommend Strathmore Mixed Media)

Don't feel bewildered; you are not about to be asked to cut up and glue down your stencils! This is about looking at your stencils and picking out sections of a shape (like a flower) or random squares (like a grid). The key is to not look at your stencil as a whole but rather look at the individual parts.

Any width pen is fine for this exercise. You might like big, thick black lines or you might prefer fine lines. Whatever you choose, make sure it's a permanent pen so the ink doesn't bleed when you add color later. PITT artist pens or Pigma Micron pens are great for this.

Find the shapes you most like and go over them with your black pen. Don't worry if your pen wobbles a little; it's part of the charm. Look at where shapes you've traced overlap and use the pen where it makes the most visual sense. The idea is to achieve a *look* of multiple layers on your page without the bulk of layers of paper!

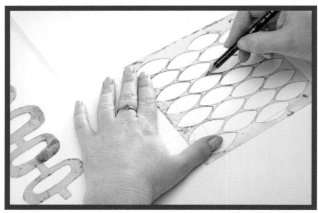

1 Select Stencils
Look through your stencils for sections that are useful. I often start with 12" × 12" (30cm × 30cm) background stencils, such as polka dots or a grid. Using your pencil, lightly trace the stencil on your paper.

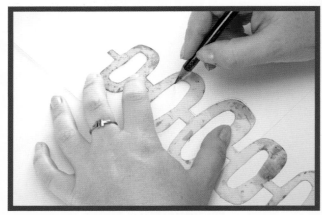

2 Play with Larger Elements
Now pick out some larger shapes from your stencils. You might like to create collage sheets with a theme or keep it random. Anything works. Don't get too hung up on what you choose because the idea is that the sheets will be cut up at a later stage. Lay some of these larger images over the top of your sheet and mark them with your pencil.

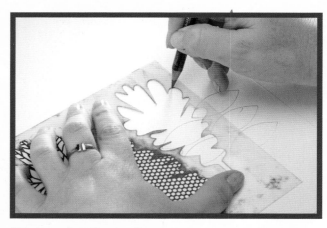

3 Overlap Some Areas
Begin overlapping some of the elements.

PRO TIP
Make your pencil markings heavy enough to see but very light in color. You will want to be able to easily erase them later. I recommend using a 2B pencil.

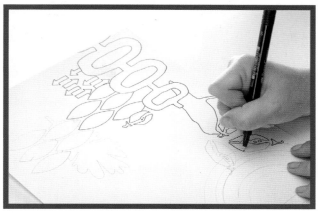

4 Continue to Fill Space
Continue layering images in pencil. Look for random shapes, lines and squiggles that can fill space. Make sure they overlap. The aim is to avoid large white areas.

5 Trace Pencil Marks with a Pen
Go over your stencilled pencil marks with a pen. In areas where you overlapped stencil designs, decide which elements you want to keep in the forefront and which will go behind. Keep inking the pencil markings until you have a completed page.

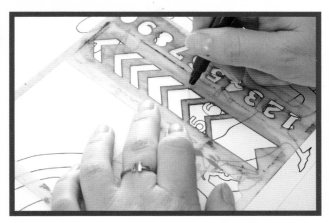

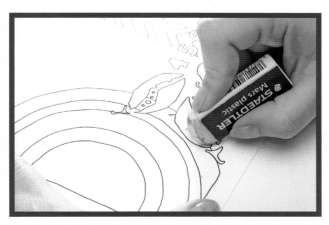

6 Add Patterns If Needed
If you feel like there's still empty space that needs to be filled, create more marks with a stencil.

7 Erase Pencil Lines
Once the black pen is dry (they dry almost instantly, but I like to give it a few minutes so the ink has fully absorbed into the paper), take out your eraser and erase all the pencil lines that you didn't draw over, plus any little marks you missed when using your pen.

PRO TIP

This is where you decide to either scan or photocopy your collage sheet of line drawings or just move ahead with coloring. Scanning is a great option because you can then reuse your sheet many times with all kinds of different colors, patterns, papers and more. So many options!

Adding Blocks of Color

There are so many ways to add block colors to your journaling pages: paint, colored pencil, markers and more. The only limit is what you have on hand and the finish you're after. I suggest printing some black-and-white copies and then playing with different materials to see what works for you. Maybe a combination of all of them?

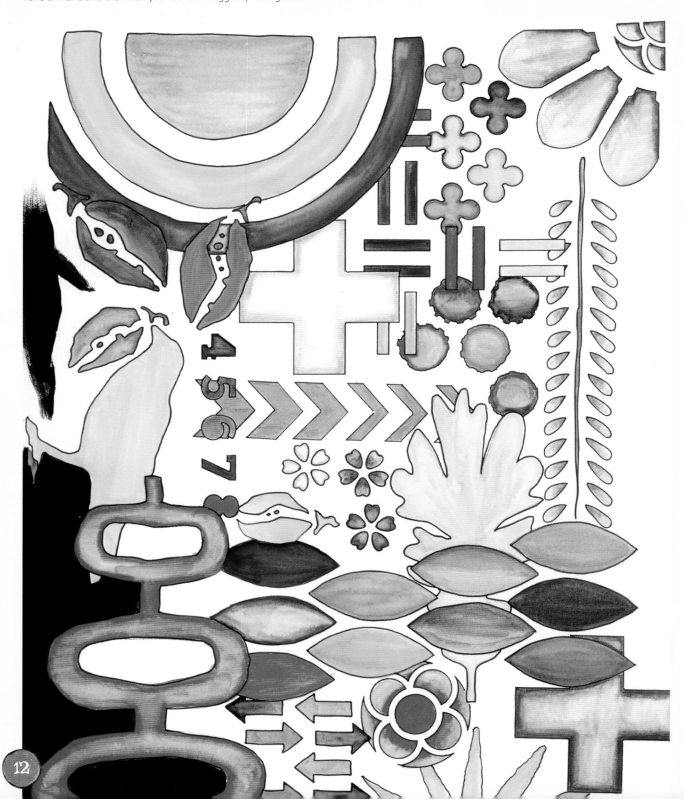

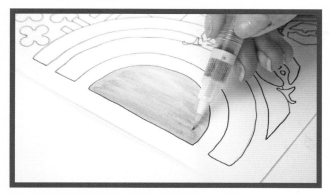

1 Decide on Your Color Palette

The first decision you need to make is whether you want a sheet with a full rainbow of colors (like we'll have here) or a more limited palette. (This is where having copies of the uncolored sheet is handy because you can do a variety of sheets and use sections of the sheet that work best.) Pick a shape and begin coloring.

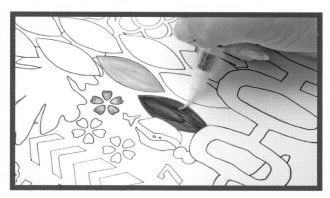

2 Use an Assortment of Colors

Continue adding color as desired.

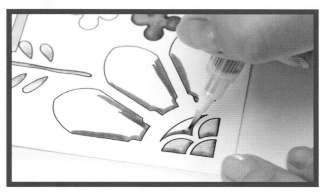

3 Try a Bit of Shading

If you like, experiment with lighter and darker areas within the shapes you color in. Applying heavier color around the perimeter of the shapes creates interest.

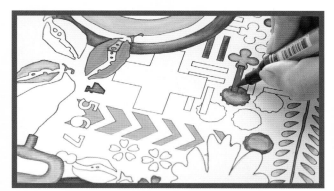

4 Continue Coloring in All of the Shapes

Continue having fun with color until the whole page is colored.

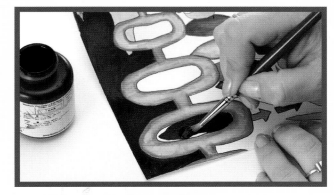

5 Fill in the Background

When all of the shapes are colored in, consider filling in the background with color, too. Lighter colors can be more forgiving for your first try, but a dark color, such as black, can really make your colors pop. Use acrylic paint or another marker to do this. When you're cutting the page up later, you may find the white parts distracting.

PRO TIP

You might like to scan your colored-in pages, too. If you are savvy with photo-editing software you might be able to add texture to your page or even change/brighten/mute colors if you want to.

Adding Patterns

Adding doodles and patterns to your painted pages is so much fun. A black pen and a little imagination will be all you need to do this!

If you have my previous books *Zentangle® Untangled* or the accompanying *Zentangle® Untangled Workbook*, you have a significant resource of patterns and doodles you can reference immediately.

But don't stop there: Lots of other books can be found, as well as websites, where you can find a ton of ideas for this type of art. The sky is the limit!

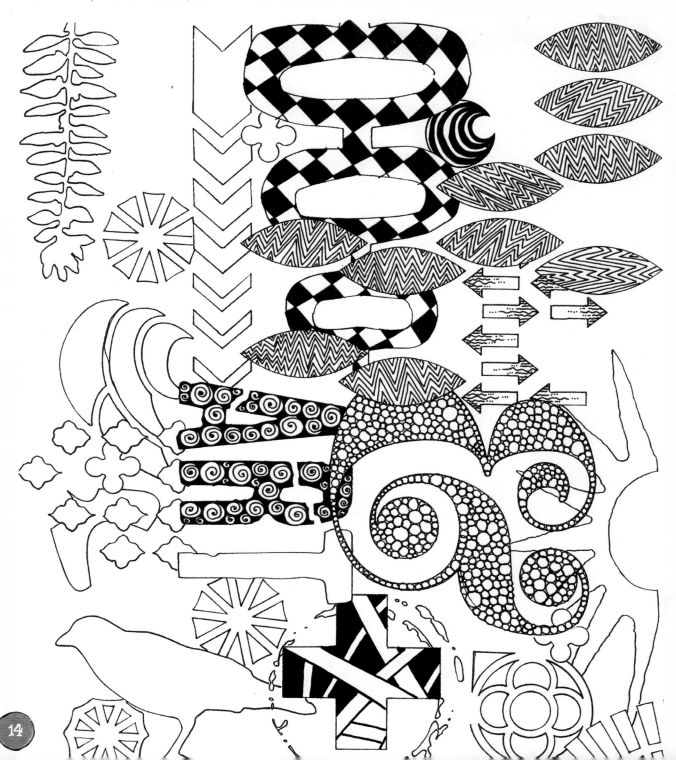

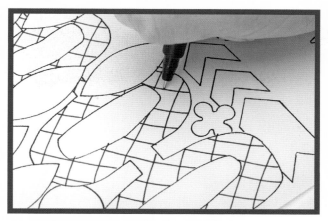

1 Begin with Simple Lines

Using a permanent black pen, pick a stenciled shape and create a repetitive pattern in it. You can randomly choose where to put patterns. A simple grid pattern is an easy one to start with.

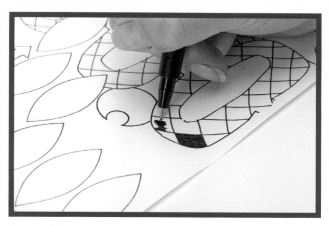

2 Add Depth with Solid Areas

After drawing the lines in one shape, you may want to use the pen to color in some of the smaller shapes.

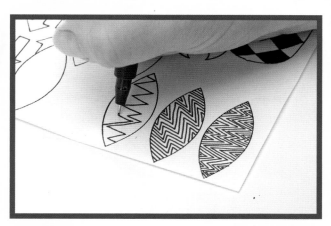

3 Repeat Patterns in Similar Shapes

Repeat particular patterns in similar or same shapes for a cohesive look.

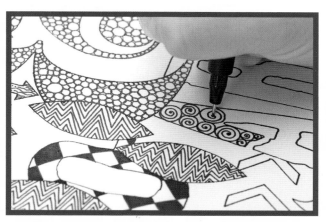

4 Fill in as Many Shapes as You Like

Continue to create different patterns and fill in different sections of your collage sheet. You might choose to fill in all of the sections or just some—that's up to you!

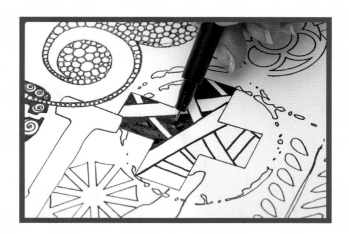

5 Continue with Some Solid Areas

Fill in some of your pattern with solid areas of black to add depth and interest.

Incorporating Patterned Papers

Every crafter has patterned papers, be they old scrapbook papers, gift wrap, newspapers and catalogs, old sheet music or card-making supplies. Yes, you know I'm talking about you, right? Well, pull those papers out and use them to create unique collage sheets no one else will have.

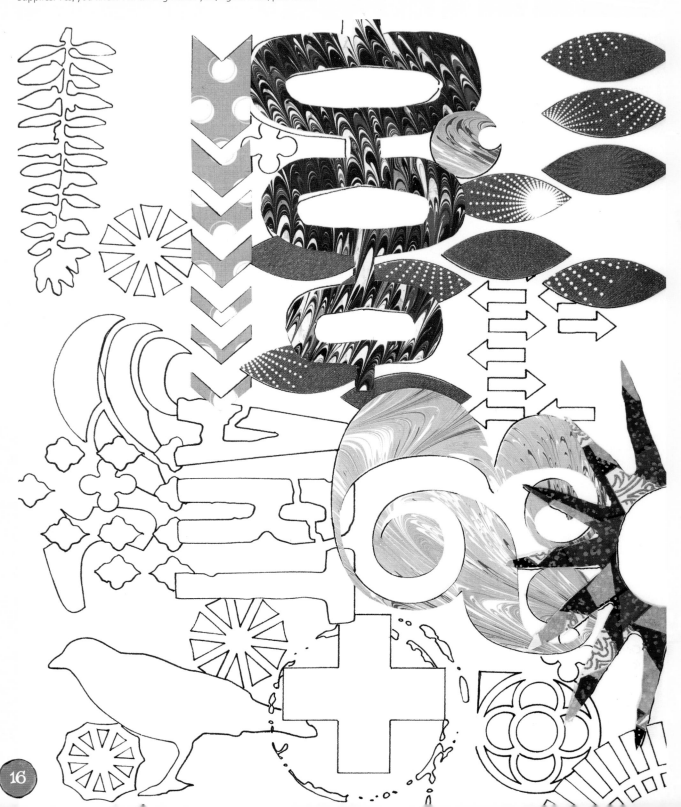

1 Trace Shapes on the Back of Paper
Choose some shapes from your stencils and lay them down on the back of your patterned paper. Remember that if your shapes are words or phrases, to place it down upside down. Trace the desired number of shapes with your pencil.

2 Cut Shapes Out
Cut out your shapes along the pencil lines.

3 Begin Adhering Shapes
Once you have a collection of shapes, start gluing them onto your white sheet of paper.

PRO TIP
If you're using a stencil with repeating shapes, turn the stencil to different angles between shapes so you get varying directions of the paper's pattern on your cutouts. This makes for a much more interesting collage later.

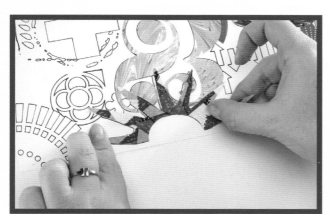

4 Continue Adding Cutouts
You can collage the entire page this way until there are no large white areas, or you can leave some of the stenciled areas as is.

Once you have placed your patterned papers down, use your stencils to create additional shapes over and around the papers. You can then fill these in with your own line pattern drawings or color in with blocks of color. The aim is to cover all of the white space.

PRO TIP
Your pages might feel a bit too dimensional to use as collage sheets at this stage. I recommend scanning and reprinting them so the actual collages in your journals sit flat (unless you love dimension, in which case, use them as they are!).

Adding Rubber-Stamped Imagery

Remember what I said about having patterned paper? Well, let's continue the confessional and admit that rubber stamps are part of being a crafter and we all own a few. More than a few? This is where we get to use them in a variety of ways to create collage sheets!

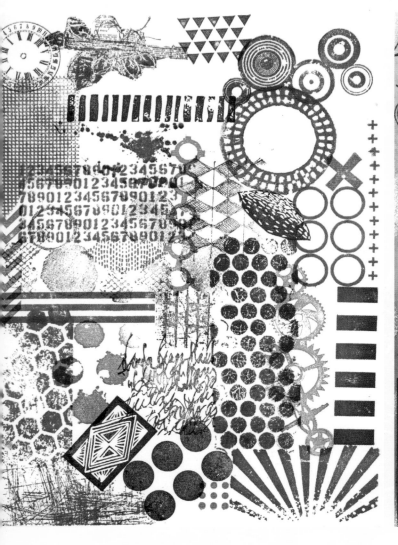

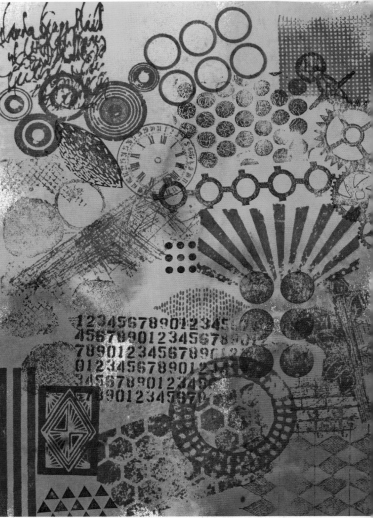

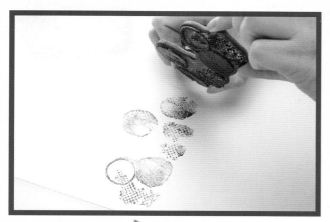

1 Begin Stamping on New Paper
On a new piece of paper, use black permanent ink to begin stamping images.

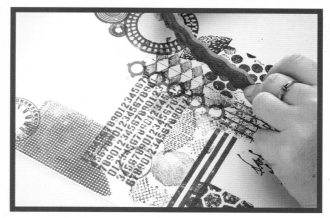

2 Use a Variety of Stamps
Stamp with a variety of different shapes. I also recommend trying different colored stamp pads. One of my favorite techniques is to use both black and gray. (Ranger Archival Ink in Watering Can is a good choice.) The effect is subtle but pleasing. I also like to throw in a little red to mix it up sometimes.

PRO TIP
Stamp your images in different directions and allow for some overlap. You'll see great results!

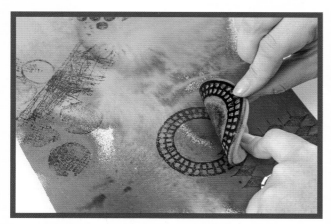

3 Stamp Onto a Colored Background
You can also color your page first using spray inks. I recommend choosing lighter colors so your black stamped images are clearly seen.

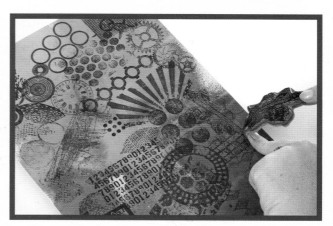

4 Fill the Sheet with Stamped Imagery
Continue stamping images until your page looks full.

Combining Stamps and Papers

Why not collage with patterned papers *and* use stamps? It's easy and effective to do both. Start by collaging your patterned papers, then add stamps in the gaps, letting your stamps overlap onto the papers.

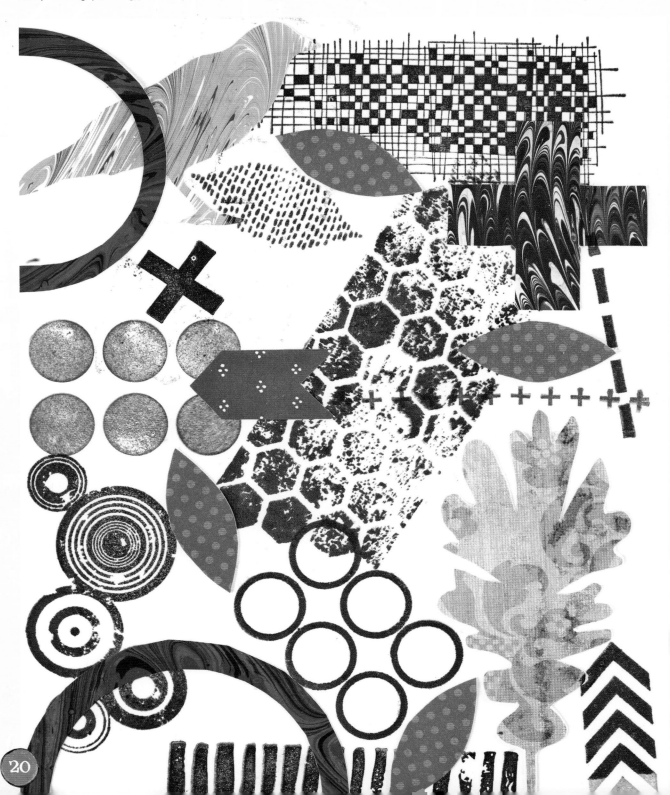

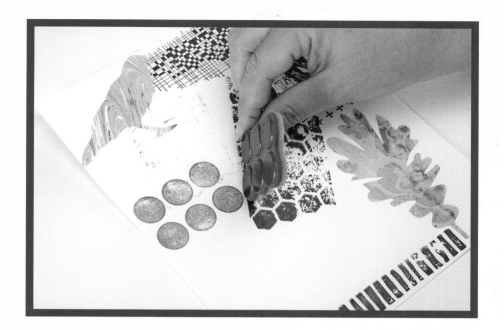

1 Stamp alongside Patterned Paper Shapes

Begin stamping onto blank areas of the paper.

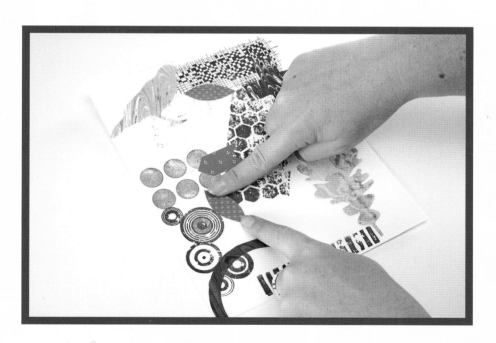

2 Alternate Paper and Stamping

Adhere patterned shapes over some of the stamped areas. Feel free to stamp on top of the paper shapes.

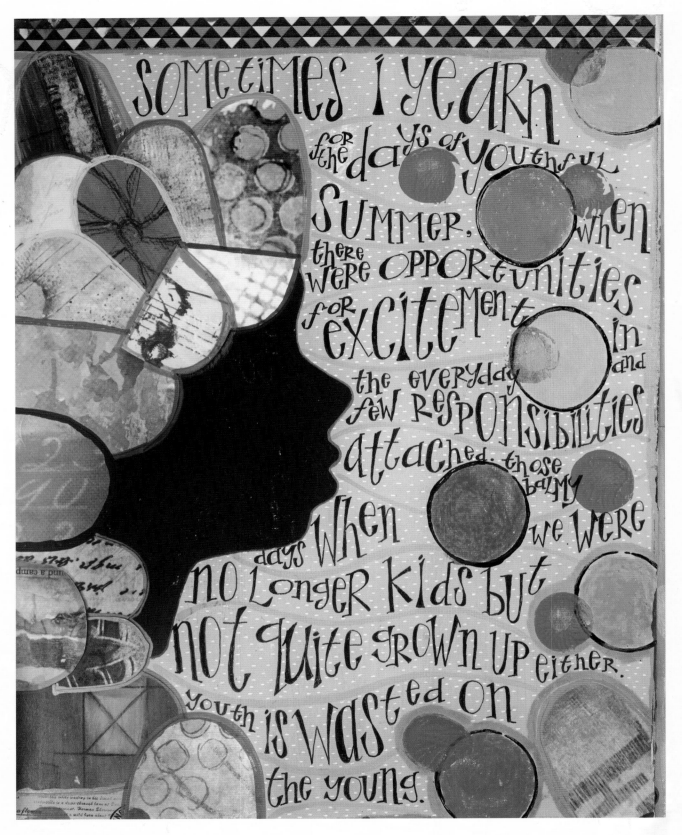

Sometimes I yearn for the days of youthful summer, when there were opportunities for excitement in the everyday and few responsibilities attached. those balmy days when we were no longer kids but not quite grown up either. youth is wasted on the young.

This page is a combination of collected collage papers and some of my own. Using collage papers for hair is a great way to use lots of different papers. Here I've used the papers by cutting them into arch shapes and layering them. The shapes not only create the hair effect, they also create the point of interest on the left-hand side of the page, opening the right side to the text and circles.

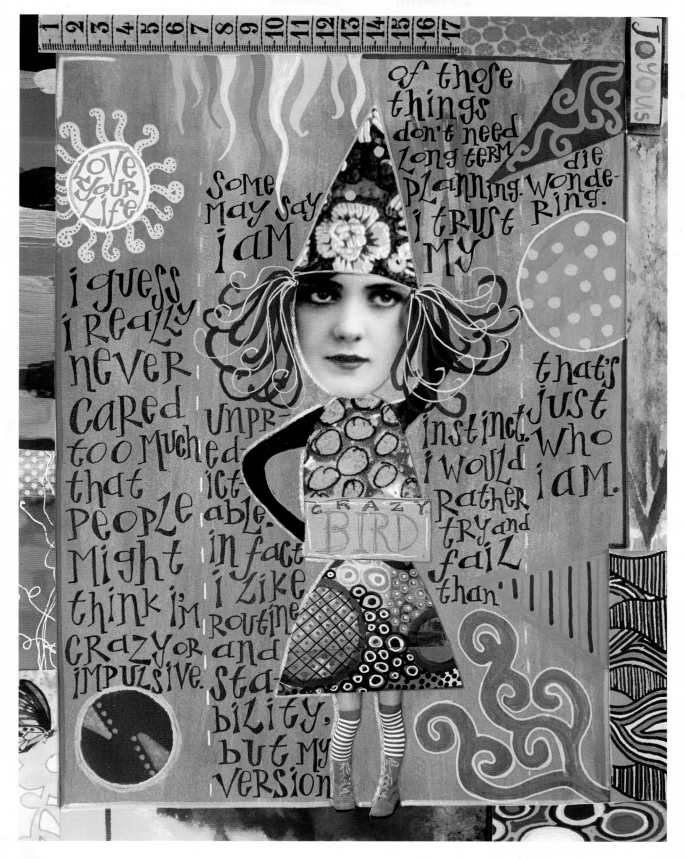

Love your Life

Some may say i am

of those things don't need long term planning. wonde-ring. i trust my die

i guess i really never cared too much that people might think i'm crazy or impulsive.

unpr-ed-ict-able. in fact i like routine and sta-bility. but my version

instinct. i would rather try and fail than'

that's just who i am.

CRAZY BIRD

I've always been told I'm too impulsive. It is true that I can be so, but I am also someone who likes routine and my impulsiveness usually fits inside the boundaries of my routines. This page is probably impulsive. Collage pieces were thrown down and drawn over without a lot of thought put into it. You can learn from just playing sometimes.

Exploring Notan

In 2014, I was lucky enough to take a class on black-and-white composition with Michelle Ward. Part of the class was dedicated to the ancient Japanese principle of notan—the balance of light and dark in design. While I understood the principle itself, I'd never heard of notan and, as I tend to do with new-to-me concepts, threw myself into learning about it what I could.

I got lucky in New York City a couple of weeks later, where the incomparable Strand bookstore on Broadway unearthed an original edition of the seminal notan title *Notan: The Dark-Light Principle of Design* by Dorr Bothwell and Marlys Frey. Having searched in stores across the city and online and coming up empty, this was an exciting find (with a price tag that was very agreeable!). A 1968 original—I was in love!

It struck me quickly that by stripping back to the basics of black and white, a whole new element could be brought to my own work and particularly my art journals. I also recognized the possibilities of tying in doodling and creating drawn patterns as part of the notan concept.

There are so many ways to create images using the notan principle. If you are computer savvy and know programs like Adobe Photoshop or Illustrator, you have endless possibilities at your fingertips. For those who prefer old-fashioned art making, I have created examples using two materials: paper cutting and black/white paint markers. I've also utilized stencils as well as hand-drawn elements. These ideas are just the beginning of what is possible, depending on your patience and desire to explore the principle.

What is great about notan is that it is possible to create amazing artworks with the most basic, least expensive materials available.

Materials to Gather

cardstock or medium-weight paper: black and white (I like Strathmore 6" × 6" (15cm × 15cm) Artist Tiles

craft knife

eraser (white)

gel pens (or paint markers): black and white

glue stick (or preferred adhesive)

pencil

ruler

scissors

self-healing cutting mat

stencils

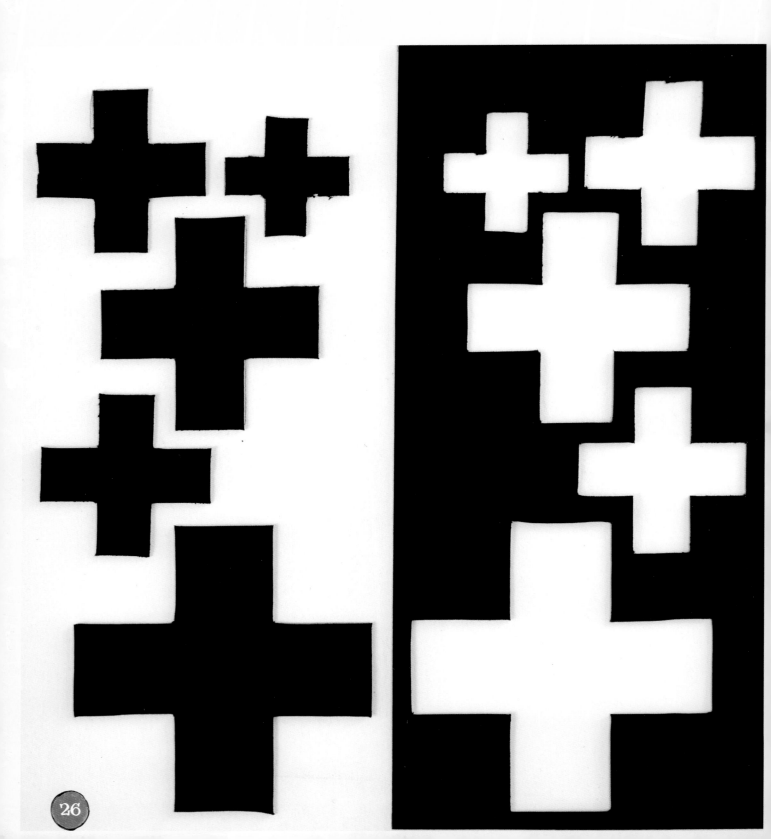

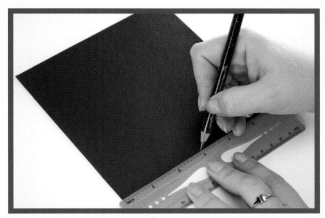

1 Measure the Center of the First Sheet
Begin with a black piece of paper. If you're not using a Strathmore Artist Tile, cut your paper to a square, approximately 6" × 6" (15cm × 15cm). Using a ruler, find the center of the paper and mark it on two opposite sides.

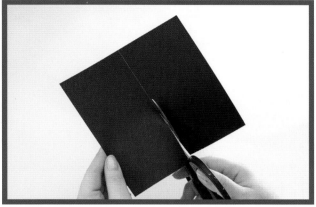

2 Cut the Paper in Half
Draw a line down the center, connecting the two marks. Then cut the paper in half along the line using scissors. Set aside one half of the paper.

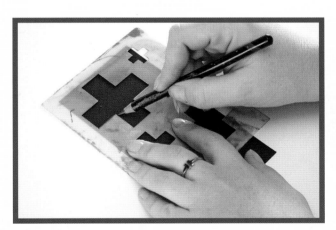

3 Trace a Few Shapes
On whichever side you'd like to be the back, use a stencil and pencil to trace a few simple shapes.

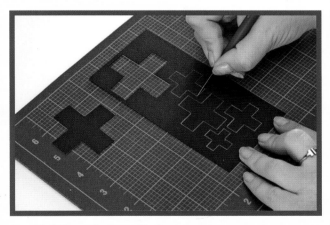

4 Cut the Shapes Out
Working on a self-healing mat, cut the shapes out using a craft knife. Don't discard the cutouts.

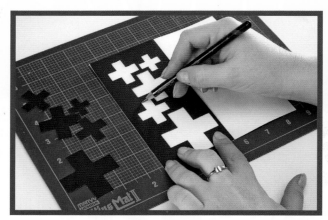

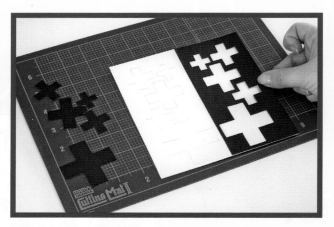

5 Trace a Few Shapes

Cut a piece of white paper to the same size as the full black piece (6" × 6" [15cm ×15cm]). On one half of the white paper, place the black half facedown and use a pencil to lightly trace the placement of the shapes.

6 Cut Out the Shapes

This should give you a reflection of shapes when you flip the black piece back over.

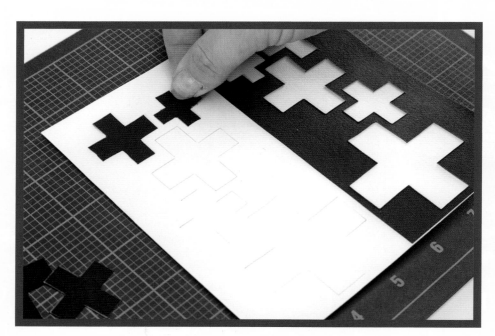

7 Trace a Few Shapes

Adhere the cutout shapes in their marked spaces and adhere the black piece on the other half.

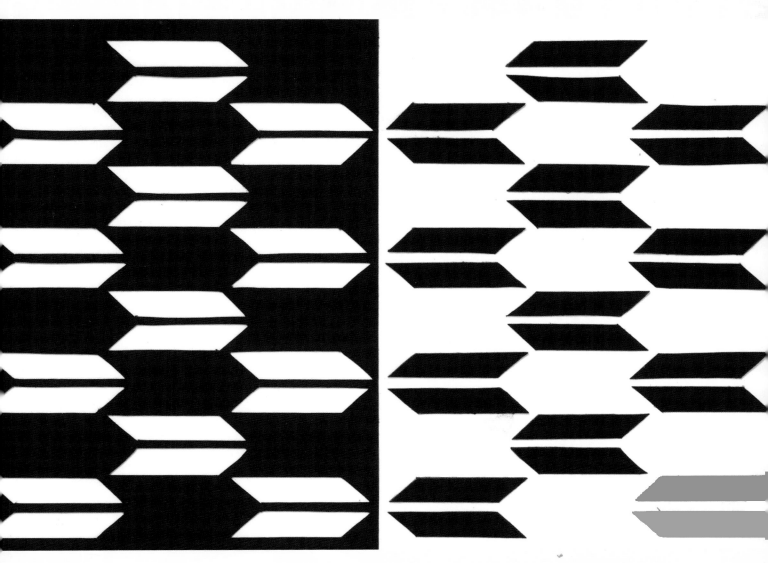

This is a basic design using an ArtistCellar.com stencil, and it gives you a great sense of what we are trying to achieve with notan—the balance between light and dark. The compositional balance is clear, thanks to the simplicity and symmetry of the design.

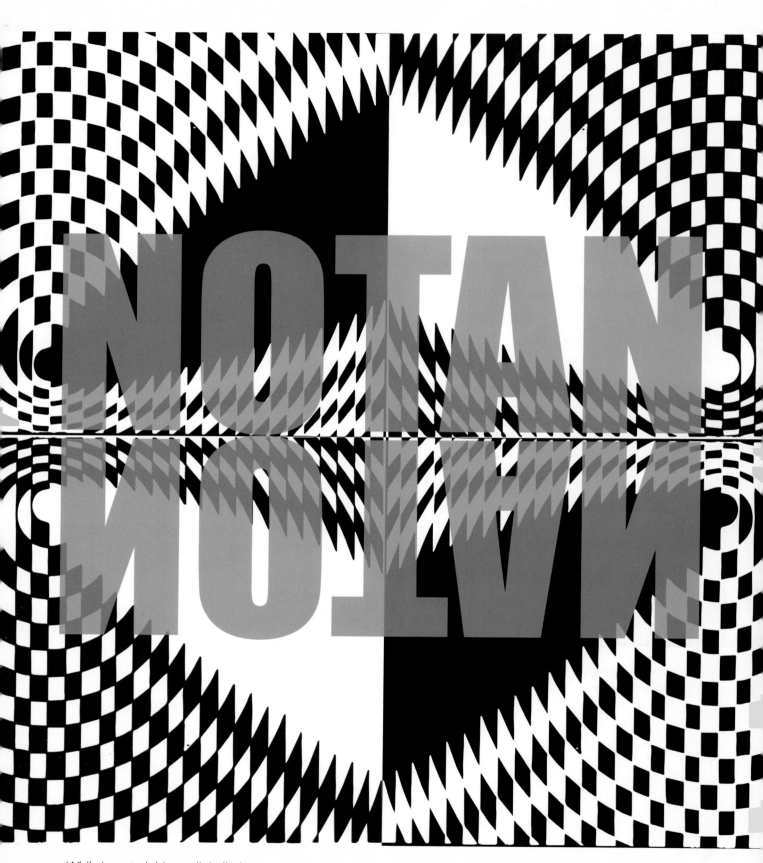

While I created this art digitally, it's an example of how even simple lines and shapes can be powerful and create a lot of punch.

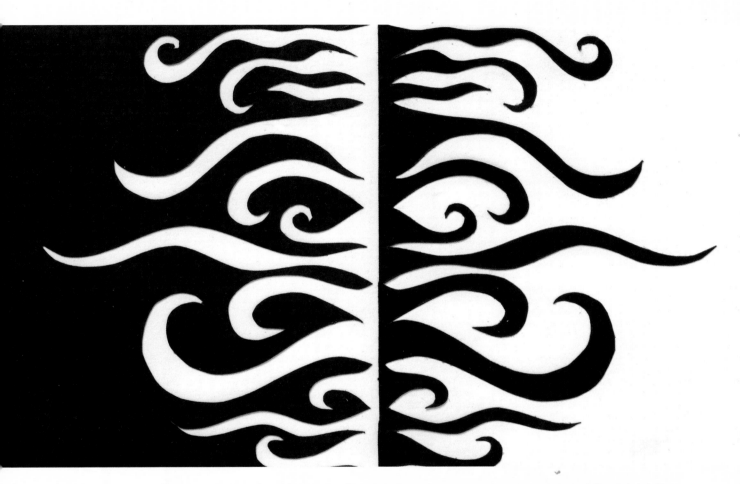

For this relatively simple design, I drew "flames" down the side of the black piece, cut them out and flipped the shapes over to create the mirror image. I use flames as an element a lot in my journals.

Freehand Notan

Now that you're warmed up, we'll try this next exercise in the same way, using the same materials. But this time, instead of using a stencil to get our shapes we will play with drawing a design freehand.

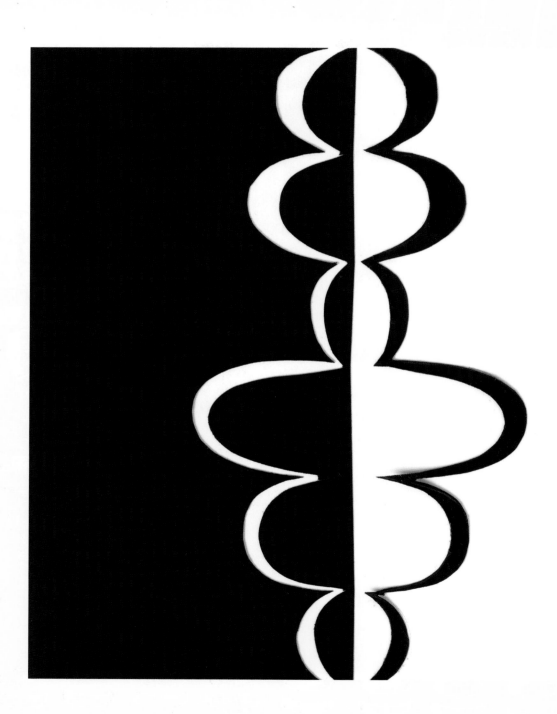

1 Draw a Simple Design

Using a pencil on a half-square of black paper, freehand draw a simple design.

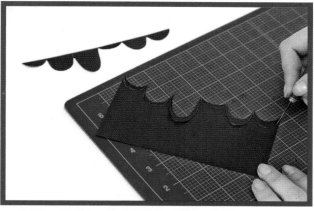

2 Cut Out the Design

Cut out the doodle, using your craft knife or scissors, depending on the complexity of your design.

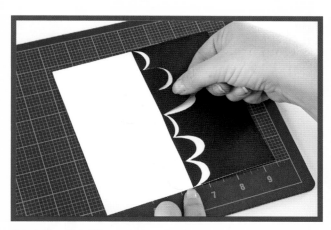

3 Flip the Elements

Flip over the black sheet and the portion you cut out onto a full square of white paper.

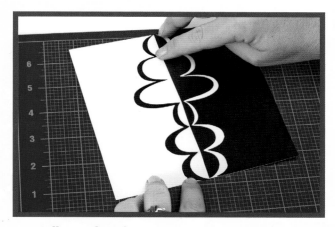

4 Adhere the Elements

Adhere the cutout portion onto the white paper using glue and adhere the mirrored black elements on their half. This completes the mirror illusion.

Intermediate Notan

Let's up the ante here and look for some slightly more complex shapes within the stencils we have. These can be shapes that are not symmetrical but still interesting. For this exercise, we'll be working in individual blocks in the same way we worked with single larger squares.

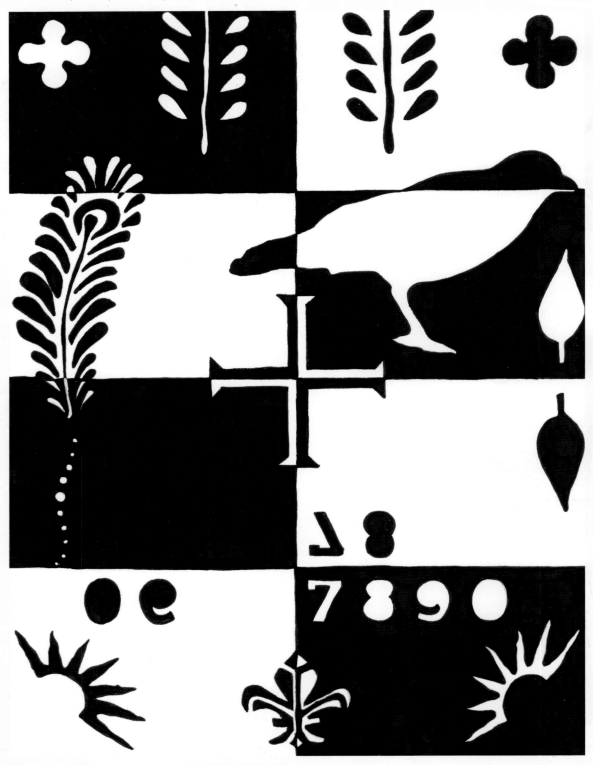

Using Stencils in Blocks

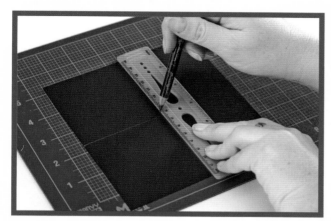

1 Divide Paper into Quarters
Divide a full square (such as an Artist Tile) of black paper into quarters by ruling a line at the center points top to bottom and side to side, creating a cross.

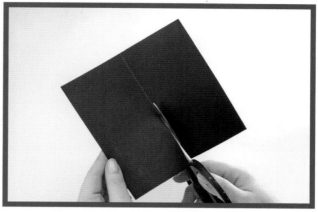

2 Cut into Smaller Squares
Cut the paper along the lines into four smaller squares.

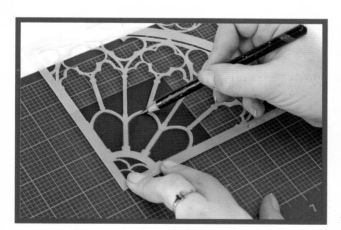

3 Trace Some Stencil Elements
Outline portions of a stencil onto your paper. Avoid shapes that run off the edges.

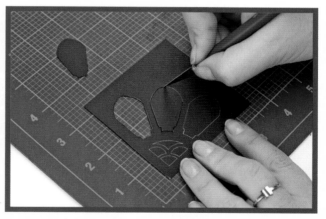

4 Cut Out the Elements
Using a craft knife on a cutting mat, cut out the traced pieces.

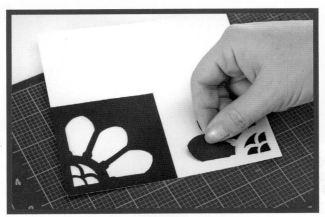

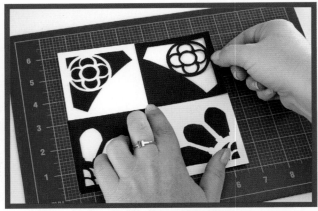

5 Adhere Paper for Lower Blocks
Adhere the black paper to the lower-left half of a full square of white paper. Flip the stencil and mark out a mirrored map of where the cutouts go on the lower-right half of the paper. Adhere the cutouts in the marked spaces.

6 Create Two New Upper Blocks
Repeat the process with a different stencil, but this time put the black paper on the upper-right half of the full white sheet and the cutout black pieces mirrored to the left, creating a complete four-block notan.

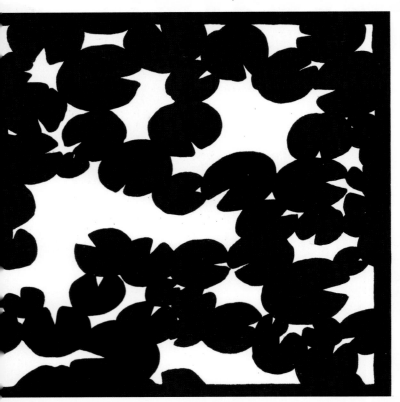

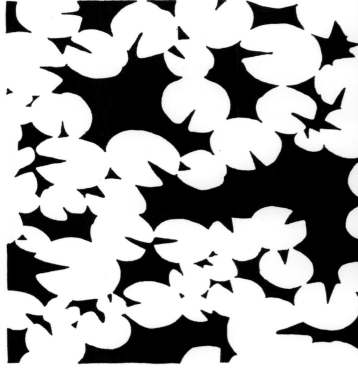

In this example, I used another ArtistCellar stencil. This is a straight render of the stencil. A render, you ask? Yes! Instead of cutting paper with this more complex stencil, I colored it with a black marker after marking it out with a pencil. Cutting such a detailed stencil would have tested my patience beyond what I possess!

Freehand in Blocks

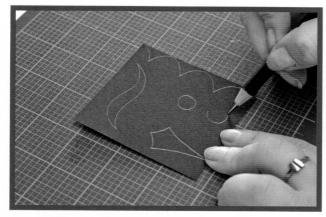

1 Draw a Simple Design
Cut a black square into quarters. Begin with one small square and freehand draw a simple design.

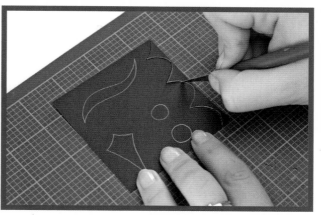

2 Cut Out the Elements
Using a craft knife, cut out the elements. You'll probably find your craft knife more efficient with your own hand-drawn shapes than it was with the commercial stencils, since these shapes are a natural extension of your hand.

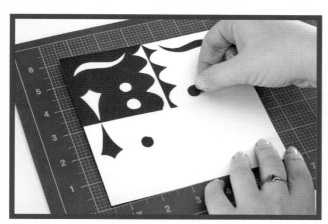

3 Experiment with Placement
Place this first black square into the top-left corner. Now play with the placement of the elements you cut out. Some may work well mirrored to the right, as we've been doing all along, but experiment with placing some below as well. When you're happy with the placement, adhere them to your white tile.

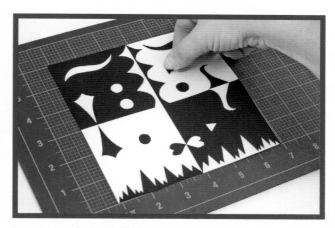

4 Complete Full Tile
Repeat steps 1–3, this time create the black lower right-hand quarter with a new design. As you create this second design, consider where you draw your shapes and whether you want them to mirror across or up (and you don't want them to cover up what you've already created).

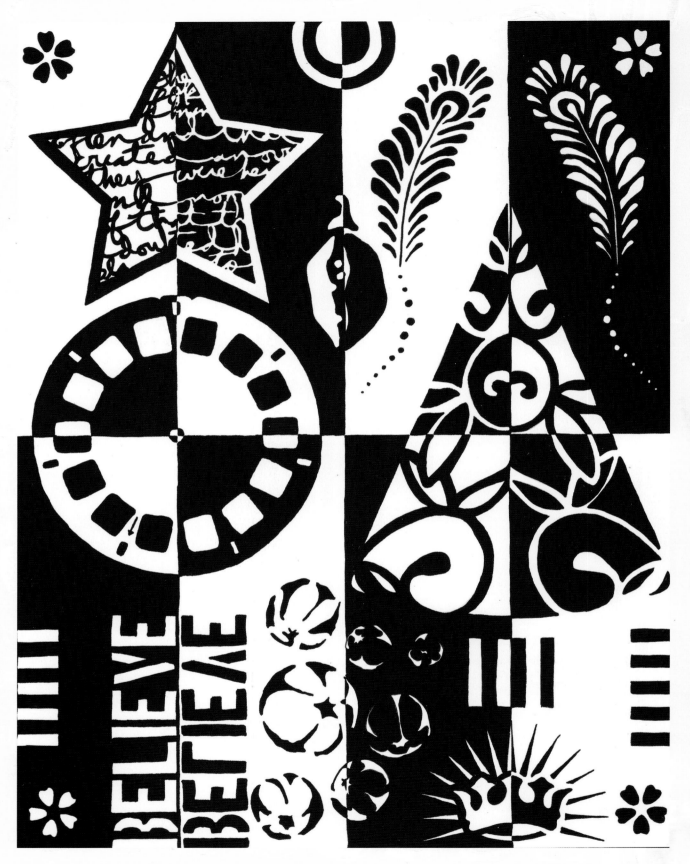

Now that I've shown you the steps for less complex ideas, I wanted to show you some more complicated designs. Look closely; you'll see some images that appear mirrored are actually not completely symmetrical (the Dina Wakley star stencil design in the top left corner, for example).

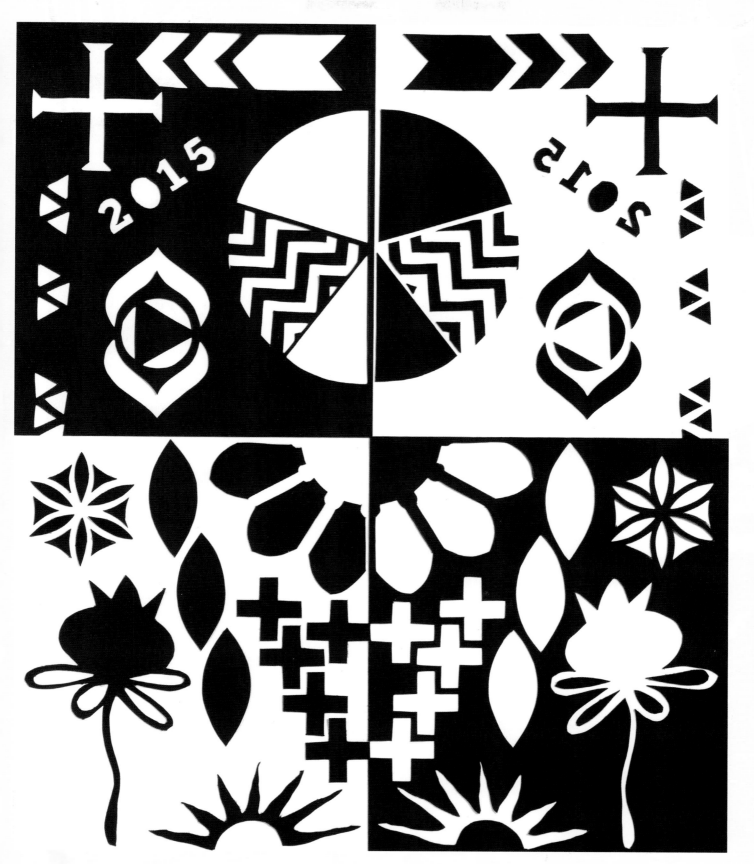

Here's an example of when I decided to use the cutting knife on something more complex. This piece took me a full day to complete because my hand became so sore from gripping the knife! Here's a word from the wise: Don't clutch your knife (or pen!) tightly. Your hand will ache, and you'll start to question why you ever started this (and then you'll question life in general and then the universe and . . . it goes downhill from there)!

Adding Patterns to Notan

When you've created your notan image, why not start doodling on it? You might choose to add some patterns in just some squares (like I have done in my finished example, opposite). Perhaps you'll draw into all the white blocks or all the black ones. You might pull out your pens and doodle into ALL of the blocks—the choices are endless!

1 Use a Pen to Draw Patterns
Create your notan design as desired. In this example, I've used a fine-point black pen to doodle onto the white sections.

2 Vary Patterns as You Go
Feel free to vary the pattern you use from section to section.

PRO TIP
A good white gel pen works great on black paper.

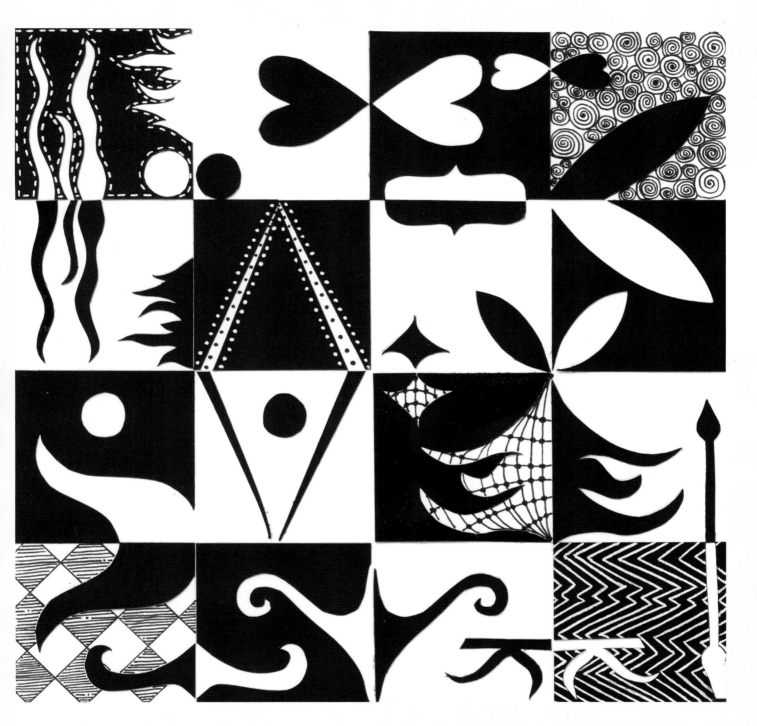

There really are very few limitations on how the concept of notan can be applied. Simply keep in mind the balance of light and dark. Trust your instincts on that and then PLAY. It's a lot of fun.

MY LIFE HAS CHANGED SIGNIFICANTLY IN THE LAST YEAR OR SO, AND I'VE CHANGED WITH IT.

I MIGHT NOT ALWAYS FEEL LIKE I KNOW WHO I AM BUT I KNOW I'M NOT THE GIRL I USED TO BE. SHE IS GONE AND SHE IS NEVER COMING BACK.

I DONT OWE ANYONE EXPLANATIONS FOR WHO I'M BECOMING. NOT EVERYONE WILL LIKE IT AND I'M OK WITH THAT. I CAN ONLY ASPIRE TO BE MY BEST SELF.

THAT IS ENOUGH. IT HAS TO BE.

IT'S ALL I HAVE.

Using Black & White Versus Full Color

It's time to really get into our journals. The most common type of journaling uses full, unabashed color—and we shall get to that before long. However, it's a lot of fun to also limit our use of color in various ways when we're journaling. We will learn a lot about what colors work well together (and which do not!), and we will challenge ourselves to extend what we've learned in new ways.

In this chapter we are going to look at creating journals in black-and-white (and all the shades of gray in between). This is a favorite way of journaling for many people, myself included. I'll offer tips on how to create incredible journal pages with just black and white. Captions accompanying the finished pages describe the process and details to look for—ideas you, too, can try in your own work.

Then we are going to look at a few ways you can limit the color palette, starting with primary colors, analogous colors and neutrals.

Finally, I'll show you a bunch of my full-color journal pages. My aim is to show you what a wide range of colors can look like when you don't hold back—vibrant colors, pastels and even neon. You'll see the strengths and weaknesses in using the full rainbow of colors available. This is an important part of the learning process: seeing when less is more and when more is never enough.

These are just a few ideas, and they will hopefully inspire you in many other ways!

Materials used: Acrylic paint, paint marker

Materials used (opposite): Pigma Micron pen, paint marker

Shades of Gray

Before we jump into the black-and-white journals, it's important to take a quick look at the different types of grays that are out there. You'll see labels like cool gray, warm gray, neutral gray and French gray. I'm only going to differentiate cool and warm grays for you, but knowing the differences will influence how your journal finishes up.

As you know, mixing black-and-white materials creates gray. However, the undertone of the black used will influence the appearance of the gray.

Cool Gray

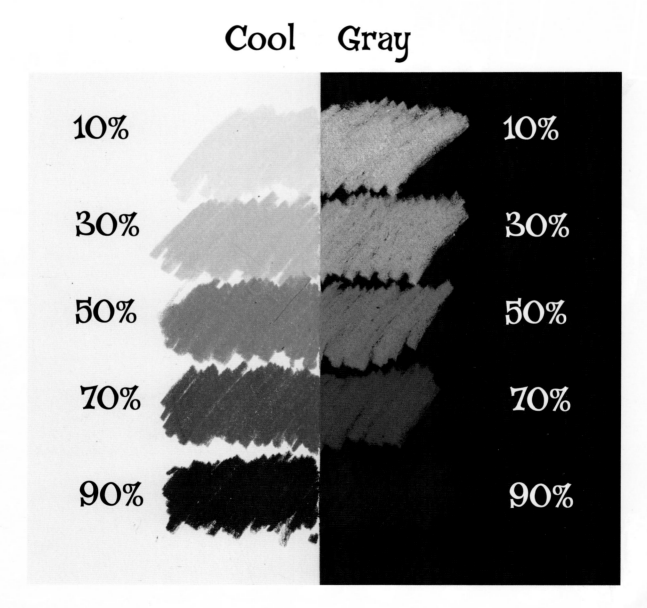

10%

30%

50%

70%

90%

Cool Grays

Cool grays occur when there is a bluish undertone in the black (for example, Carbon Black paint). The more black there is, the darker the gray. This is the kind of gray you want if your art contains predominantly cooler colors (blues, greens, some purples).

Warm Gray

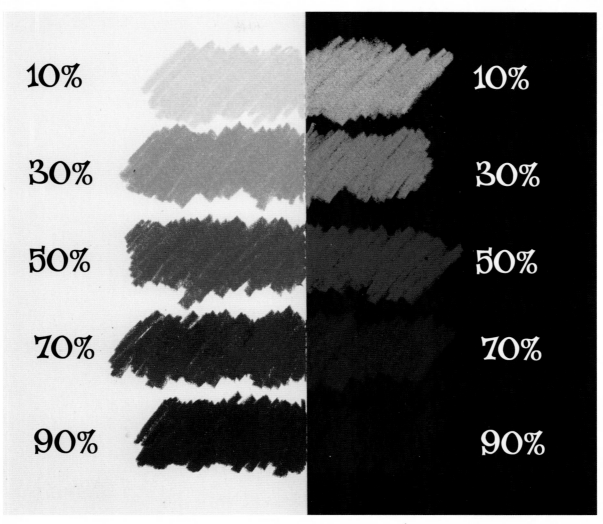

In these examples, I used Prismacolor pencils.

Warm Grays

Warm grays occur when the black has a reddish-brown undertone (for example, Mars Black paint). The same as cool gray, the more black there is, the darker the gray. However, this darkened gray, used with some colors, will look brownish. This is the kind of gray that better suits art that contains predominantly warmer colors (reds, yellows and reddish purples).

PRO TIP

A great way to experiment with grays and to get a true feel for how they interact with colors is to make some samples like I have. Do this on pure white paper and then, on either side of the grays, add red and blue. You'll really see the difference.

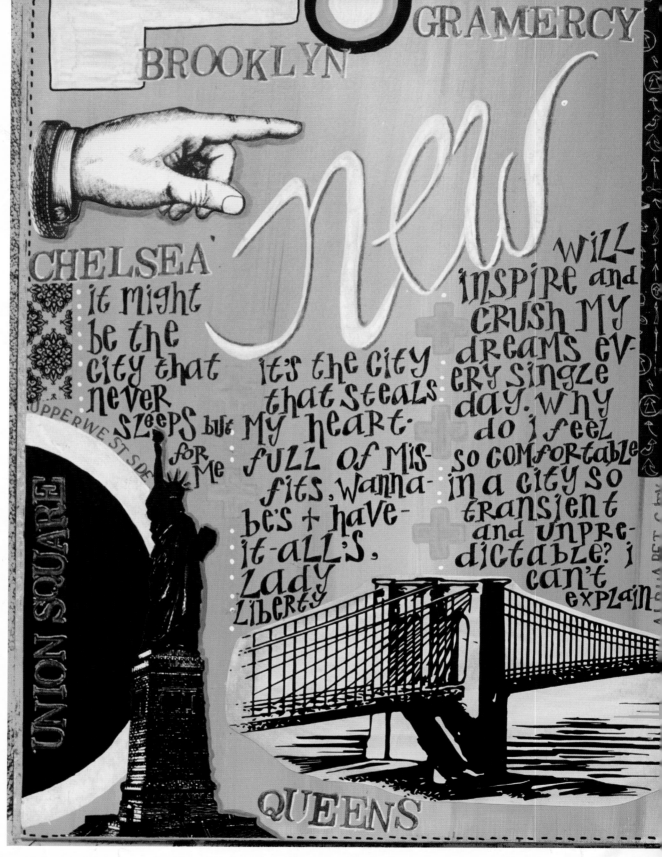

BROOKLYN GRAMERCY

CHELSEA *new* WILL

it might be the city that never sleeps but for me

UPPER WEST SIDE

UNION SQUARE

it's the city that steals my heart. full of misfits, wanna-bes + have-it-all's, Lady Liberty

inspire and crush my dreams every single day. why do i feel so comfortable in a city so transient and unpredictable? i can't explain

QUEENS

Sometimes it's fun to pay homage to the things and places that matter most to us in our journals. There have been times I've been accused of being "scrapbook-ish" in my journals (I'm not sure I know what that even means), but bringing the personal into our journals can bring both points of interest and personal satisfaction.

On this page, some of my own New York photos have been converted to black-and-white using Adobe Photoshop. Other photos are from copyright-free books (see the Resource section for more).

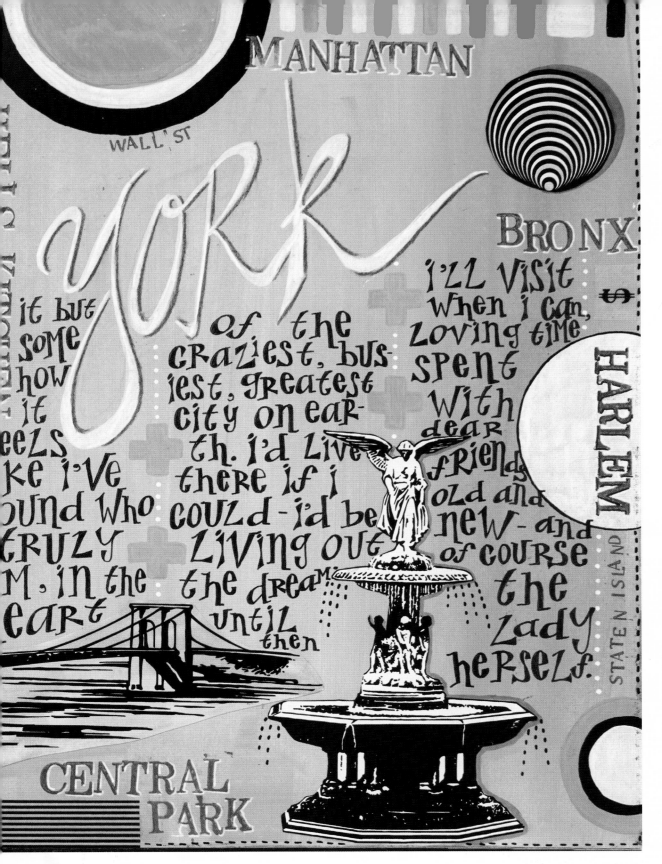

MANHATTAN

WALL ST

York

BRONX

$

HARLEM

STATEN ISLAND

it but some how it feels ke I've ound who CRUZY M, in the eart

of the craziest, busiest, greatest city on earth. I'd Live there if i could - i'd be LIVING OUT the dream until then

I'LL VISIT when i can, Loving time spent with dear friends old and new - and of course the Lady herself.

CENTRAL PARK

Many shades of gray occupy this page. In some ways the page might be better if I'd used all cool grays or all warm grays. However, there wasn't a lot of thinking ahead when this spread was created, and that's OK, too. The spread still works, but it's a good example of something to think about in advance.

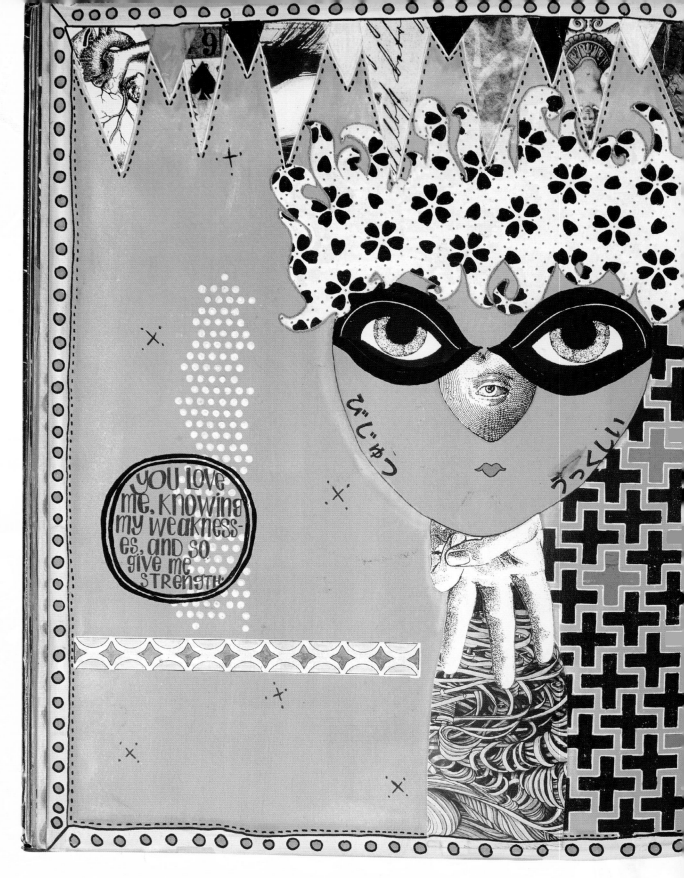

I created this page after my best friend, Katie, said something wise and supportive to me during a difficult time I was having. We haven't had discussions about which of us is which on this page; that might be stretching the friendship too far!

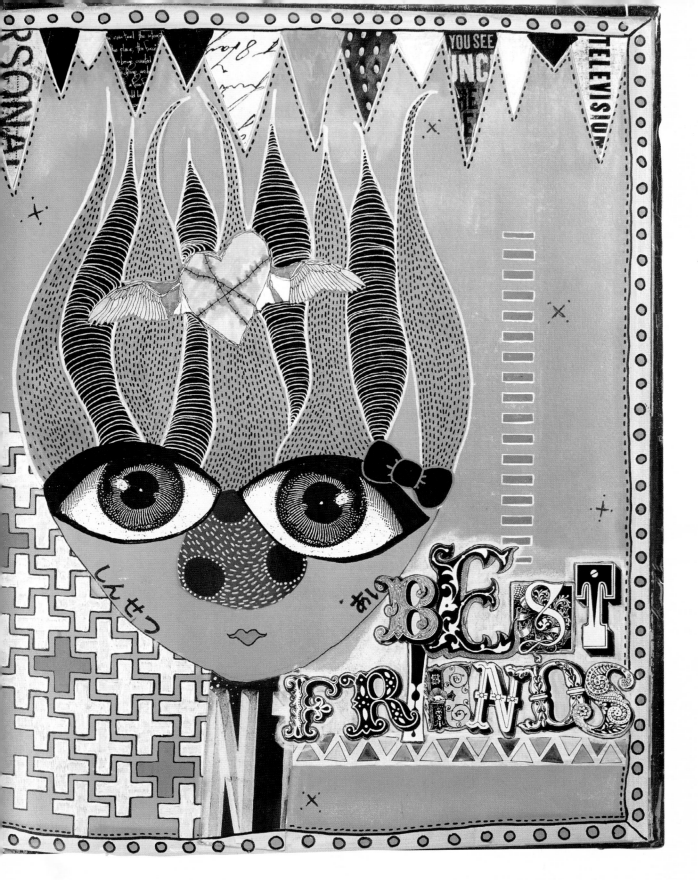

Materials: Acrylic paint, paint marker, gel pens, collage pieces, stencils, rubber stamps and ink, pan pastels, pencils

Compositions in Black & White

Now that we've established the role of grays, let's start with simple black and white. You can create an easy black background using stencils or simple drawing shapes. This background is Gelli-plate printed. I collaged various images over the top, including black-and-white washi tape.

The numbers were stencilled on using a black paint marker. I used a small amount of gray added as shadow, which gives dimension.

Many details on this page are discovered as your eye moves around, but the face in the center draws the eye first. See the band of gray around the head? That small detail brings the face to the foreground.

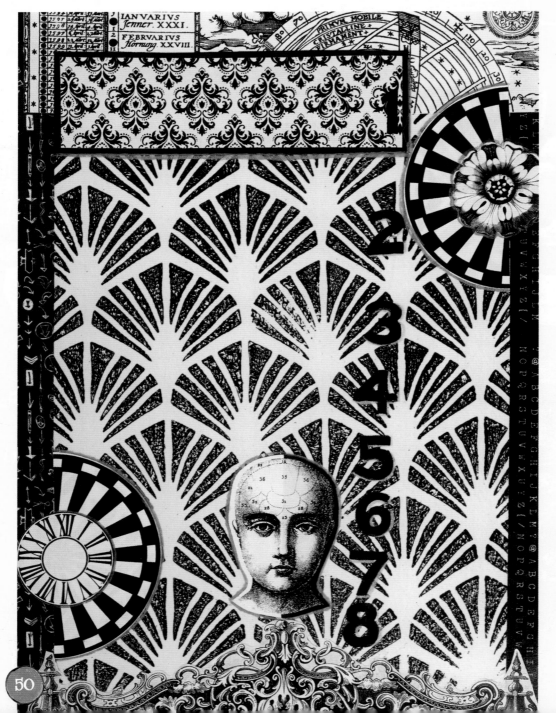

Materials used: Acrylic paint, Gelli plate, collage sheets, black paper, washi tape, gray Copic marker, gray pencil, paint marker

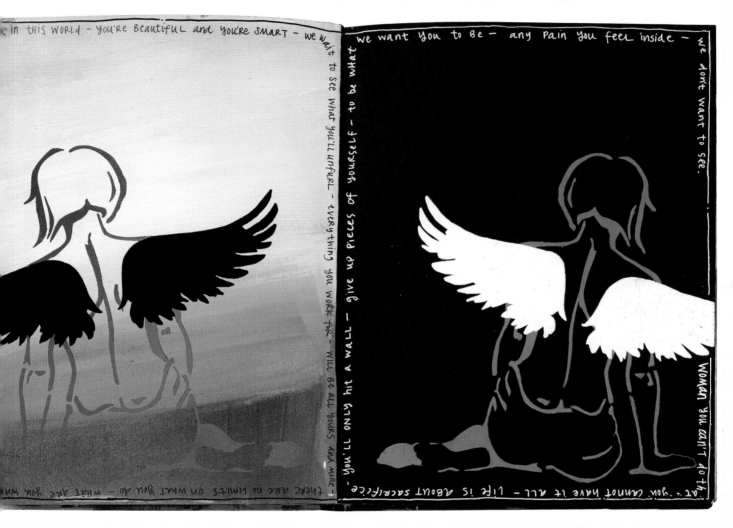

This spread originally started life as two separate pages in my journal. However, the idea of the "mirror image" came to me while working on the left-hand page. Although it's a fairly simple design overall, the detail in the stencil and wing images took some time to perfect. Art journals don't need to always be busy and dimensional, as this spread shows. The beauty of the page lies in its simplicity. The journaling reflects the mixed messages young women get about what they can and cannot do as they grow up.

Materials used: Acrylic paint, Donna Downey stencil, Typo stencil, gel pens

This page was a real battle for me because it sat for some time, feeling unfinished, but there was no lightning strike of inspiration of what was missing either. The huge black space (white space?) in the middle still feels empty, yet maybe it should be, given the theme of the page. Perhaps we don't need to fill every last space; is less really more? I want to encourage you to allow space on your pages. Not every square inch needs to be covered. The space left might just be what makes the page cohesive. Is the woman diving into a black hole, into the unknown? The deep end often feels like the unknown, doesn't it?

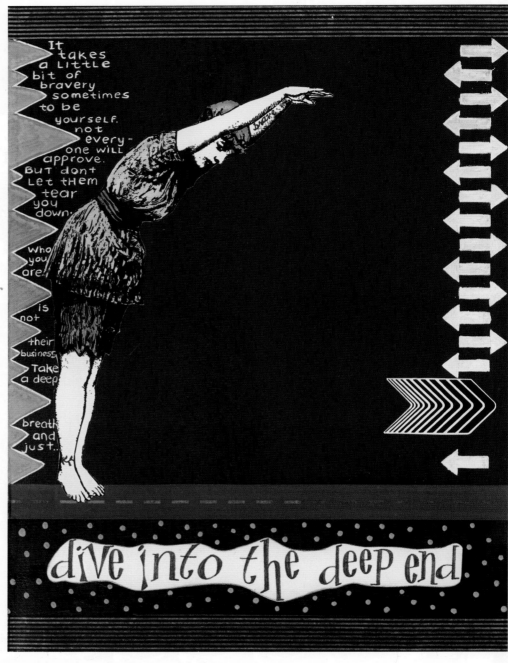

It takes a little bit of bravery sometimes to be yourself. not every-one will approve. But don't let them tear you down. Who you are is not their business. Take a deep breath and just...

dive into the deep end

Materials used: Acrylic paint, copyright-free collage pieces, paint markers, graphite pen, washi tape, gel pen, Copic marker

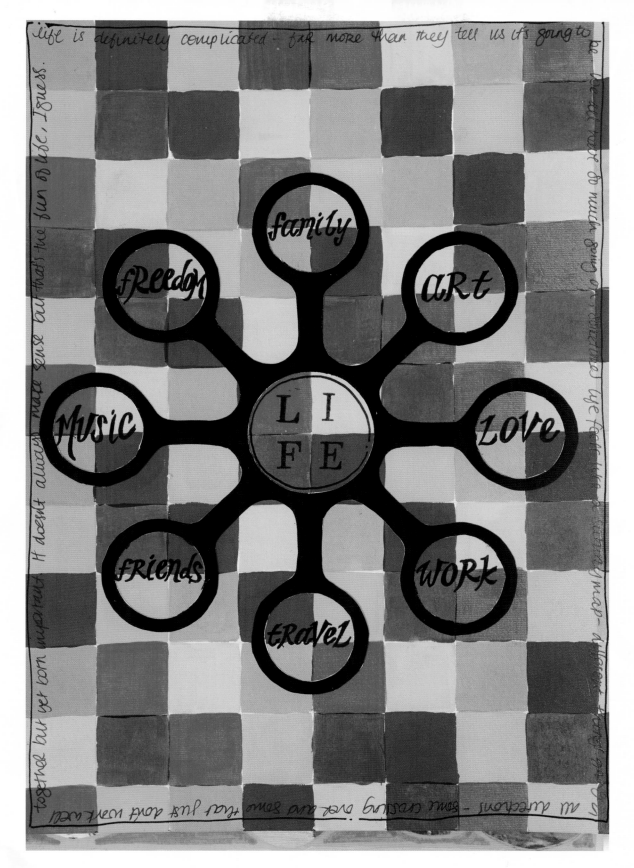

In the *Life* example, the key was the block background made with different tints and shades of the primary colors. Once I saw the effect, I didn't want to cover it too much. I was giving my overall life much thought at the time, and this stencil gave me a way to artistically convey what I'd been brainstorming.

Analogous Colors

Using analogous colors (colors next to each other on the color wheel) is another example in limiting the palette. Again, it takes away many of the decisions you'll make as you construct your page. It also gives your page a tone, an indication of the theme you'll pursue. For example, if you choose blues/greens, your page probably won't result in a feeling about the summer sunshine. Yellow and orange probably won't send your mind to winter themes, either. You get the idea.

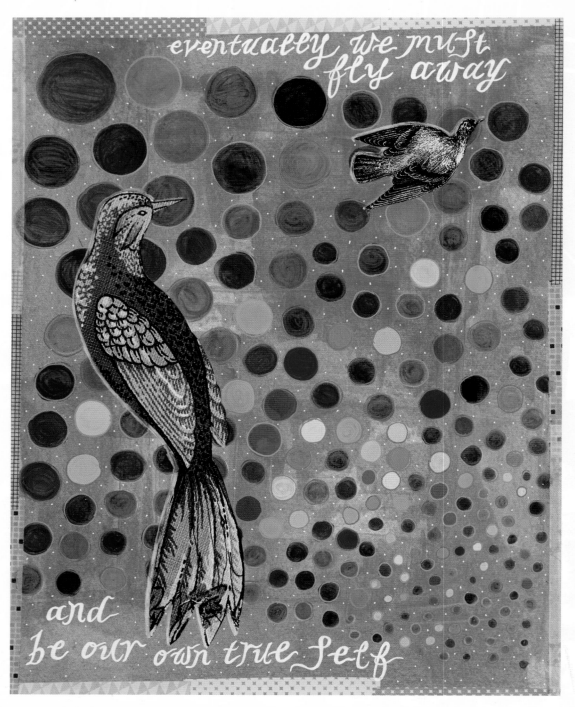

The large bird collage piece determined the colors used for this page. As is often the case, I took no set direction when I started this page; I just let it flow through me. It took weeks to complete this page because every step I took with it, I liked and was afraid I'd "ruin" it if I kept going. What you see finished is one of my personal favorite journal pages in a long time.

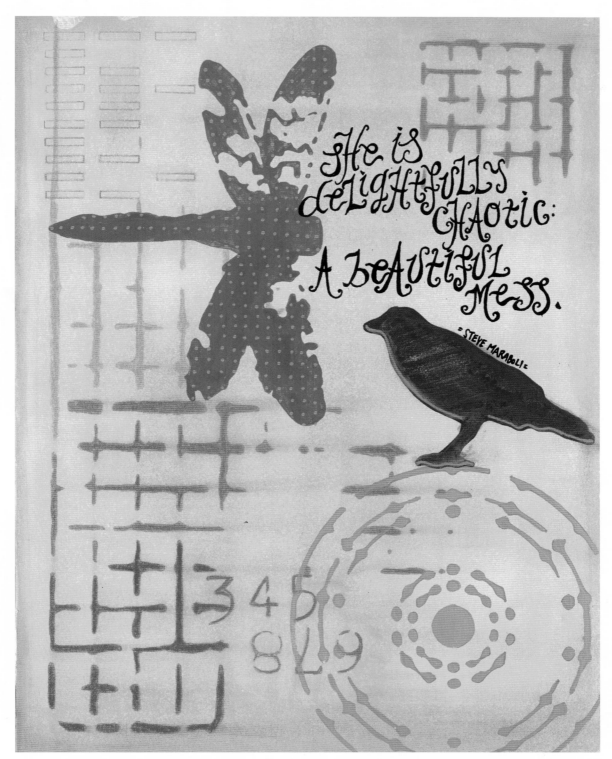

I was in my local craft shop when I saw this stencil and I couldn't get it home quickly enough. I wasn't sure what the end result would be; I just knew there needed to be pinks and reds because this stencil said "feminine" to me. I pulled out my watercolor and Inktense pencils and this is where we landed. Girly, yet a little edgy, too.

Neutral Colors

You know limiting your palette doesn't always have to involve bright colors, right? Pulling out your neutral tones—sepia, umber and earthy tones—can also be an effective way of limiting your journal palette.

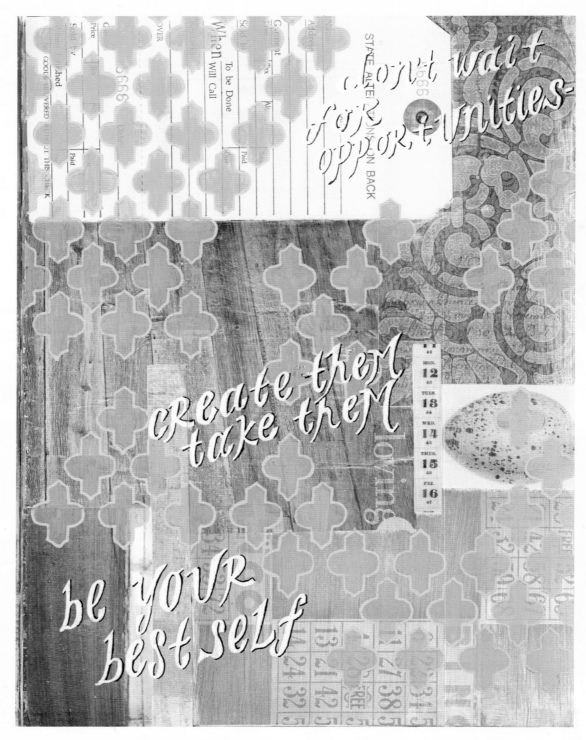

Confession: I started a journal page and it got ugly, quickly. I mean, really ugly. So I pulled out some neutral collage images and started sticking them over the top. But they were still a little bright for what I wanted, so I used a gesso wash over the top to mute the browns. Suddenly I had a page to work with!

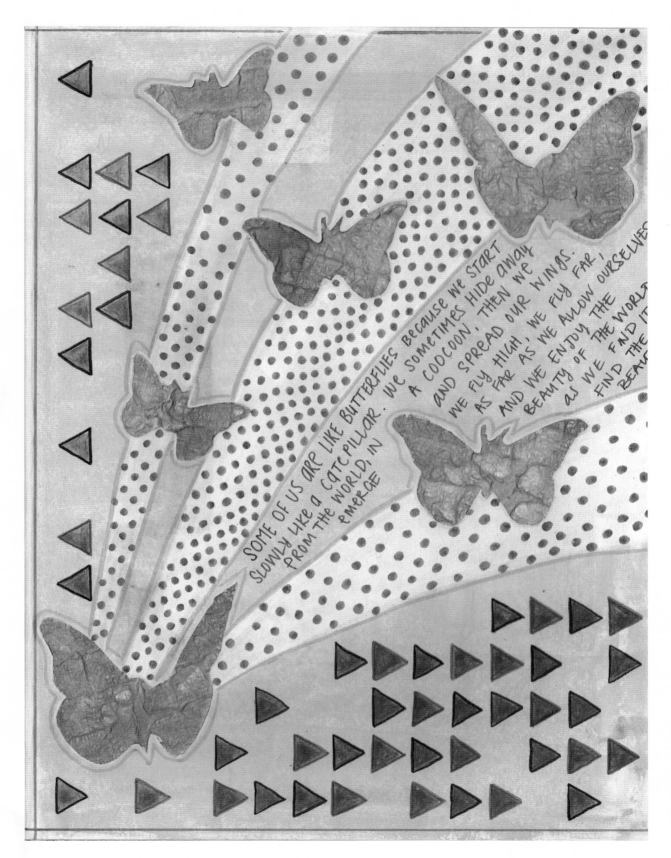

SOME OF US ARE LIKE BUTTERFLIES BECAUSE WE START SLOWLY LIKE A CATERPILLAR. WE SOMETIMES HIDE AWAY FROM THE WORLD, IN A COCOON, THEN WE EMERGE AND SPREAD OUR WINGS. WE FLY HIGH, WE FLY FAR, AS FAR AS WE ALLOW OURSELVES AND WE ENJOY THE BEAUTY OF THE WORLD AS WE FIND IT, FIND THE BEAU...

It's hard to see, but the butterflies on this page are actually textured using handmade paper. Or maybe they're moths? Can moths be so pretty?

Full-Color Journaling

This is where we get pull out all the stops, and by that I mean to unload the color wheel. We get to throw in every and any color we've got, as well as what we can create. However, there is still a method to going color mad, and knowing what works and doesn't work will inevitably improve your journal pages. The way to learn is to practice and experiment.

Don't be afraid to make mistakes, but learn from them, too. It'll bring you real joy to see things come together.

When making a full-frontal color attack, ask yourself: Do I want my page to be light or dark? Warm or cool? Do I want to use muted tones or make my page so bright I need sunglasses to look at it?

There are no rules about this; your choices are completely your own! You will naturally gravitate to your favorite approaches. You'll see I often use light colors as a background. In fact, I very often use yellow. Why? Probably because I can always darken the page if I want to, but also because you can still see details, collage and lettering on a yellow background. I really don't think about it. I just tend to start with a light color that reflects my mood that day.

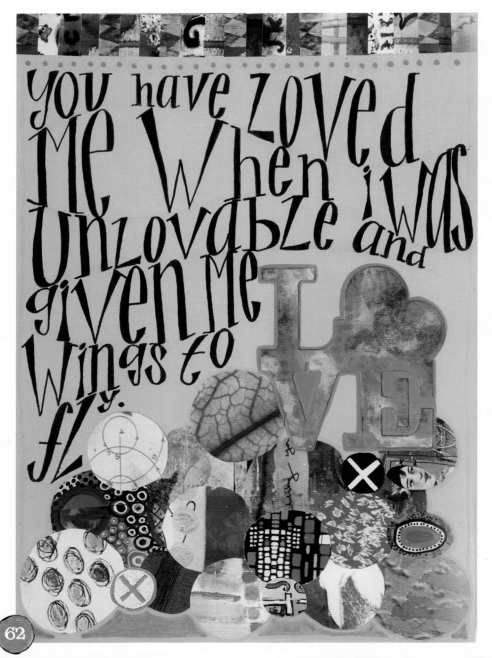

Vivid Color

You can find color everywhere, and using it without limitation can be incredibly rewarding. The collage elements are mainly small tidbits of artworks, photos and magazines. I will often scan images and then crop them down to an inch (scanning at high resolution allows me to grab tiny details and enlarge them for collage). Some are even scans from my own journal pages. It's amazing what little gems you can find in your own pages!

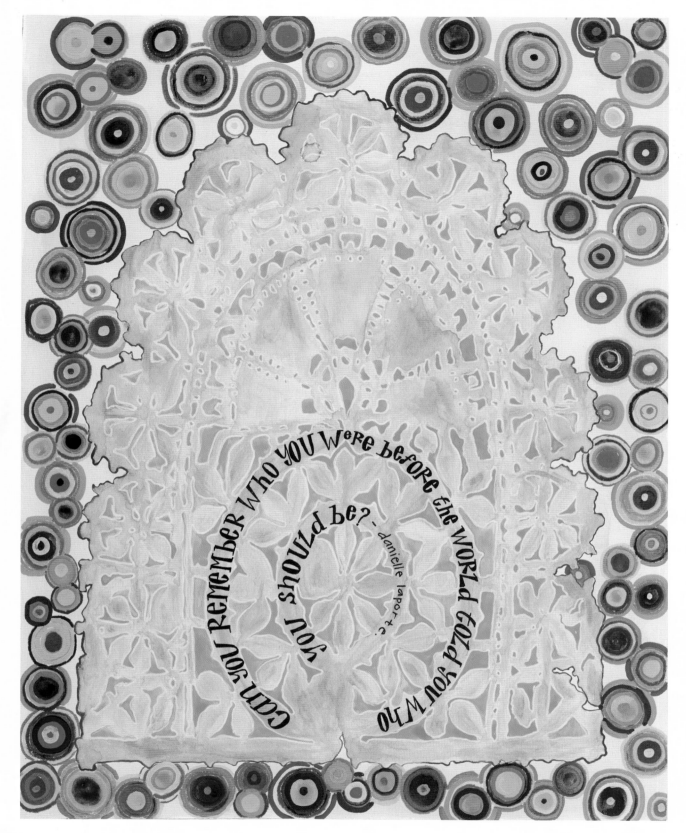

Can you remember who you were before the world told you who you should be? — danielle laporte

This image is a special one. This stencil, from The Crafter's Workshop, had me thinking about henna tattoos and the colors of India. We've all seen photos of brightly colored pigments from the marketplaces. I felt like I needed to create a page that resembled an altar or a temple and to have those bright pigments represented in some way. This page took a long time to create, but it's special to me because my Dad loves it. As much as my Dad loves me, art is just not his thing, so his enthusiasm for this meant a lot.

SOMETIMES TO GET CLARITY, YOU'VE GOT TO WRITE IT OUT.

Pastels

Full color doesn't have to mean "in your face." Pastels have been on trend for the past few years, and I wish I'd kept my original 1980s outfits (OK, perhaps they wouldn't fit anymore). This trend is great for journals, especially if the really bright and vibrant pages either are not your taste or intimidate you. It's not always as simple as adding white to colored paint to mute it, but that is a good way to start (and saves buying a separate range of colors).

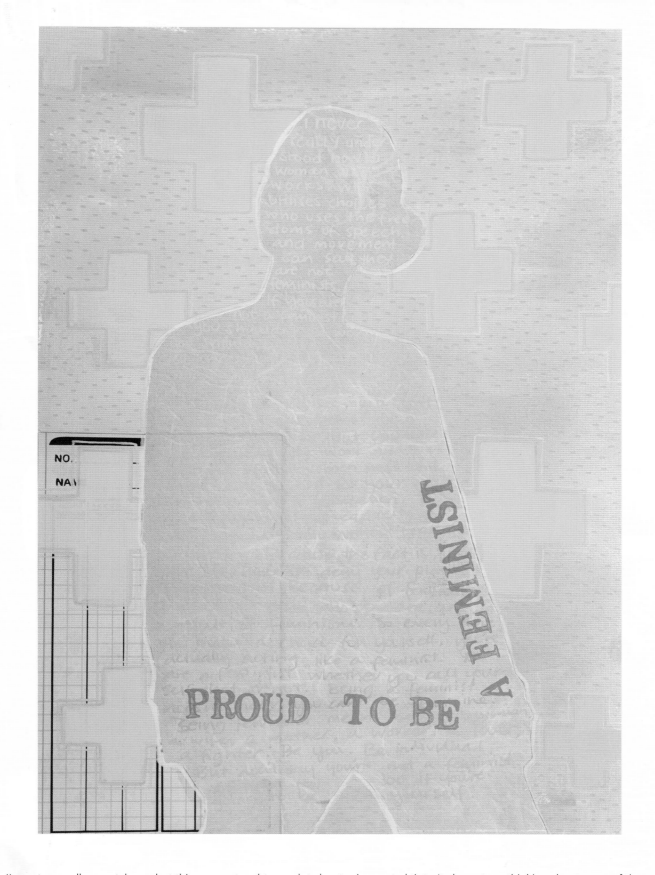

I'm not normally a pastel user, but this process taught me a lot about using muted tints. It also got me thinking about some of the preconceptions I had about using pastels: Are they *too* feminine, too soft? Or could using them, in fact, empower me to be both feminine and feminist?

Neons

Those of us who lived through the 1980s probably hoped fluorescents would stay with that decade while the rest of us moved on. Alas, neons are hip again, and when I was thinking about the concepts I wanted to show you in this book, I knew I wanted to include neons.

Here's my next confession: I have kept these two examples in this book as a lesson. I don't hate these journal pages, but I don't love them, either. I considered ditching them and doing something else. However, I kept them because (a) I wanted to show you that even professionals question their art sometimes, and (b) they demonstrate what full neon pages look like, good or bad. You might absolutely love this look, and that's great. For me, the lesson has been that I like neons as an accent or highlight—something that draws the eye—rather than the focal color scheme. The message? See what you like and what works for you. It's your journal!

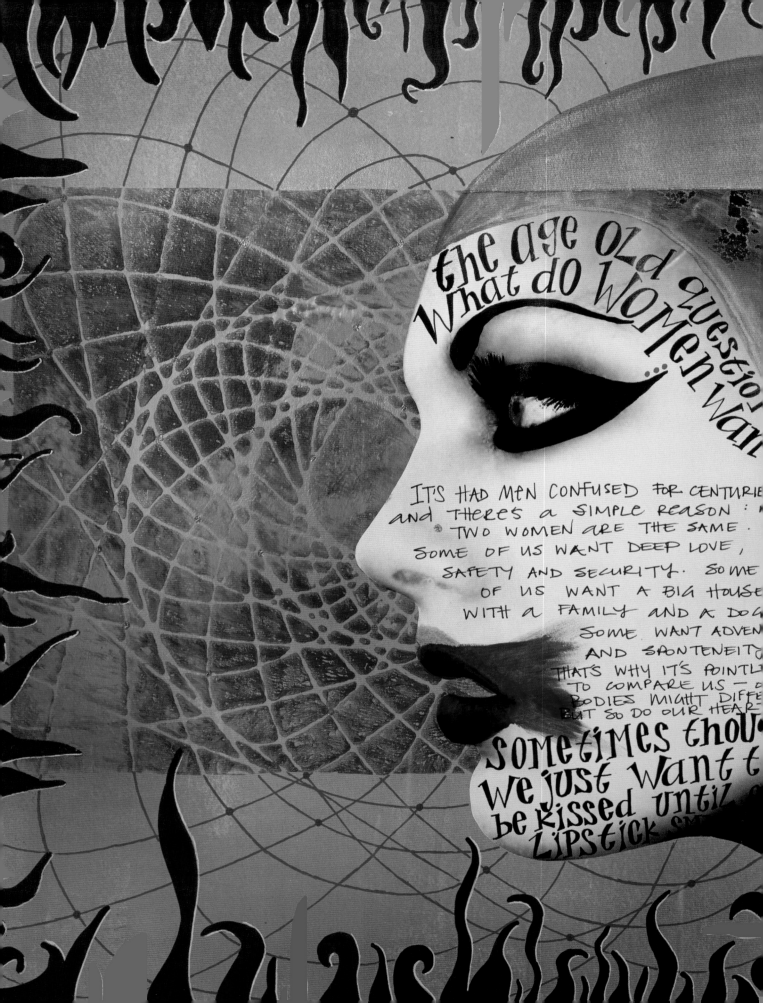

the age old question
what do women want...

IT'S HAD MEN CONFUSED FOR CENTURIE
and there's a simple reason :
two women are the same.
some of us want deep love,
safety and security. some
of us want a big house
with a family and a dog
some want adven
and sponteneity
that's why it's pointl
to compare us — o
bodies might diffe
but so do our hear

sometimes thou
we just want t
be kissed until
lipstick sm

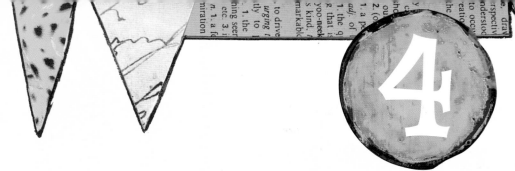

Stencils, Gelli Plate Prints & Other Tidbits

In the past couple of years, two tools of the trade have really impacted my art journals. I'm willing to bet you're no different. Those tools are stencils and Gelli plates.

Gelli plate printing is really easy, and there are many resources on how to use them. My experience is that it takes a little practice to get the hang of printing effectively, but once you have it down pat, the possibilities are endless. So many amazing artistic effects can be created using the Gelli plate. Check the Resources section at the back of this book for tips on books and websites you can go to for more complex printing instructions.

Stencils have also found their way into the art journaling world, with several companies manufacturing stencils specifically for the art and craft market. Stencils have a long history in printmaking and street art, but they are definitely a go-to tool for many art journalists these days, and the variety of what is available is phenomenal.

Stencils come in various shapes and sizes. My personal strategy is to buy stencils that have many images in one, rather than having to use one single image all the time. There are also many ways to use stencils. You'll see how to use them with Gelli plates here, as well as how to simply trace images with pencil then color them in using paints, markers, pencils and more. Don't forget to refer back to chapter 1 for tips on how to collage images; this is a great way to create both background images as well as stand-alone concepts on your pages.

Stencils really do open up a range of possibilities, and they will hopefully give you confidence with drawing in your journal, adding patterns and more.

Materials to Gather

acrylic paint (your choice of colors)

brayer

deli paper

Gelli Arts gel printing plate

paint markers

pencil

stencils

I have this really cool stencil that makes me think of space and time, and I created a print using blue and magenta paint on a sheet of deli paper. I adhered it to a purple page. The colors worked because, of course, blue and red makes purple. I found a cool image from a magazine and gave her a "makeover," and it all started coming together. The deli print is part of the page but not the whole background—I extended the lines using a blue gel pen. The great thing about deli paper is you can stick stuff on it, paint on it and write over it.

Gelli Plate Printing with Stencils

Printing onto deli paper is a fabulous way to create semitransparent prints you can use in your journal. Once the prints are dry, use some matte medium to adhere them in your journal. The deli paper becomes translucent and you can see what's underneath. I've created two examples on the following pages to show how effective this can be.

Printing with One Color

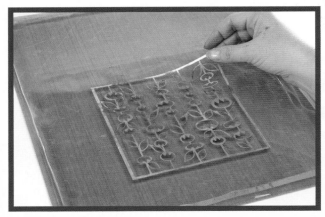

1 Select a Stencil
Choose a stencil you like and place the stencil (or stencils) face up onto your Gelli plate.

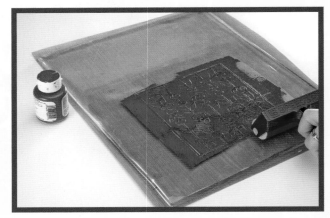

2 Roll on Paint
Squeeze some paint over the stencil and use your brayer to spread the paint across the surface of the Gelli plate.

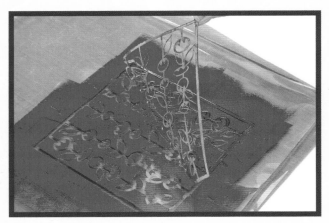

3 Remove Stencil
Gently peel the stencil off of the Gelli plate.

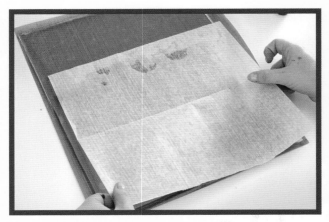

4 Add Deli Paper
Take a sheet of deli paper and place it over the wet paint on the Gelli plate.

5 Apply Pressure
Gently pat the deli sheet over the entire painted surface to ensure you get a full print.

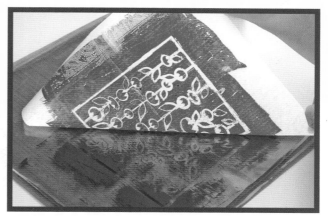

6 Lift Off the Paper
Pull the deli sheet off of the plate to reveal your print.

Printing with Two Stencils

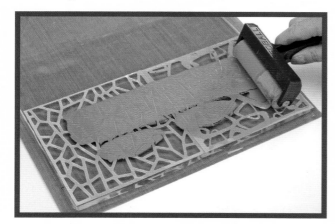

1 Place Two Stencils
Select two stencils that you think go nicely together and place them on your Gelli plate. Carefully roll paint over the stencils. You can keep the paint confined to the interior of the stencil designs or you can roll paint outside the edges; the choice is yours.

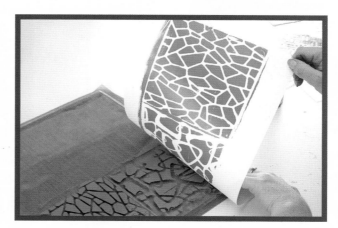

2 Peel Up the Paper
Press your chosen paper over the print, burnishing well with your hands, then peel the paper up to reveal the print.

Printing with Two Colors and Two Stencils

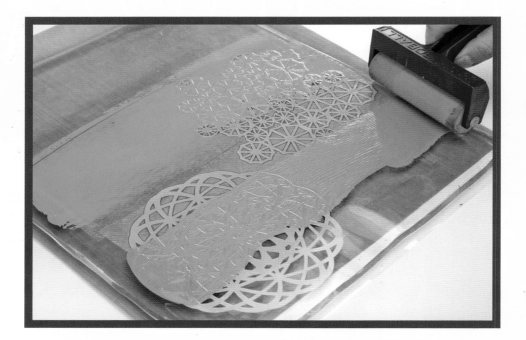

1 Select Stencils and Roll on Paint
Place a couple of stencils onto your plate and squeeze out two colors. Roll out the paint, being careful not to mix the colors together too much.

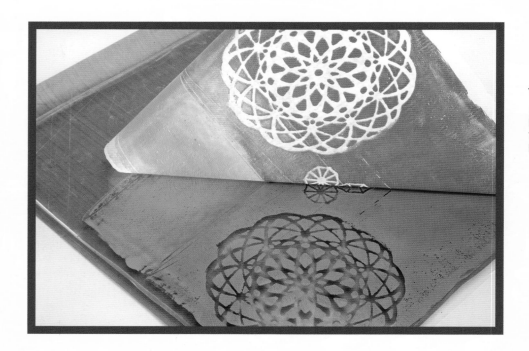

2 Reveal Print
Press paper onto the wet paint as you have previously, then pull the paper to reveal. Presto! A two-color print!

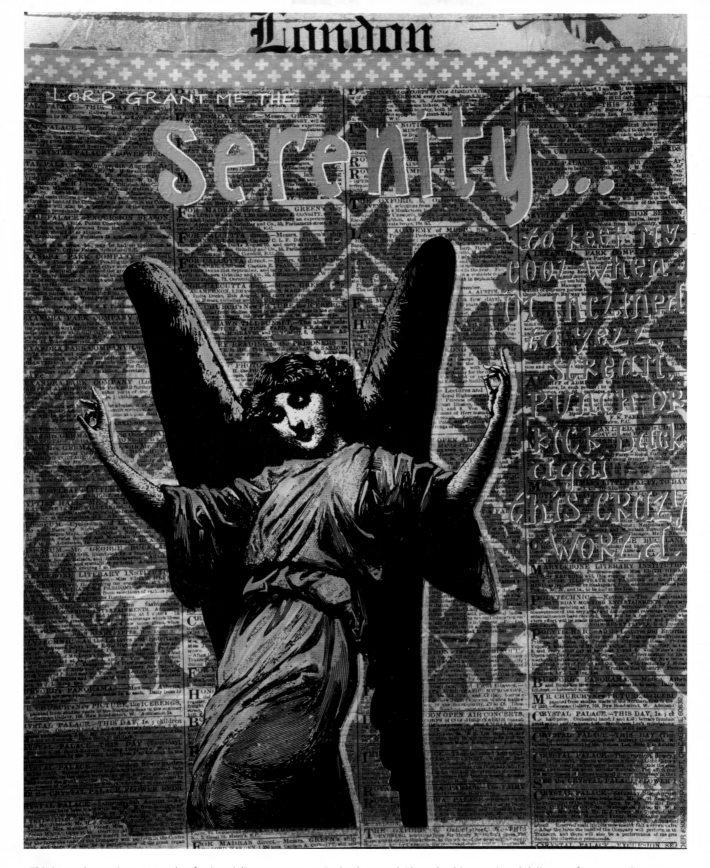

This journal page is an example of using deli paper as an entire background. I bought this preprinted deli paper from an online store; it looks like old newspaper print. I then printed on the deli paper with an Aztec-inspired Crafter's Workshop stencil in purple, laying it over the orange and yellow paper (it had a mottled effect from Dylusions ink sprays). I was able to use the whole deli sheet. There are a number of colors here; I think a plain background would have created a feeling of being incomplete.

Creating Stencilled Backgrounds

Great journal page backgrounds are easy to achieve with some stencils and some color. Here's a super simple tutorial to get you started.

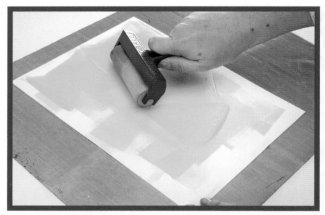

1 Apply Paint
Apply paint to the surface, and brayer it across the paper. Let it dry.

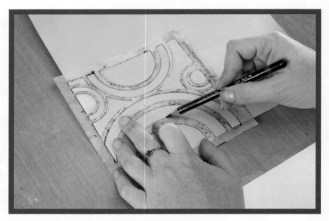

2 Select Stencils and Draw
Lay down some stencils. Use a pencil to lightly draw in the sections you want to use.

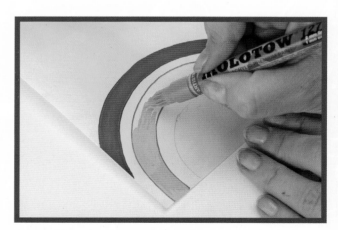

3 Add Color
Using paint markers, color and doodle some designs onto the paper. You can use any materials you want here: paints, colored pencils and/or markers.

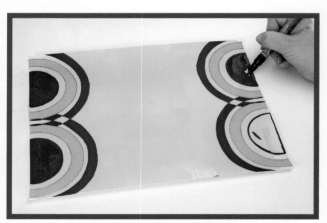

4 Finish
Repeat steps 2 and 3 until the background is finished.

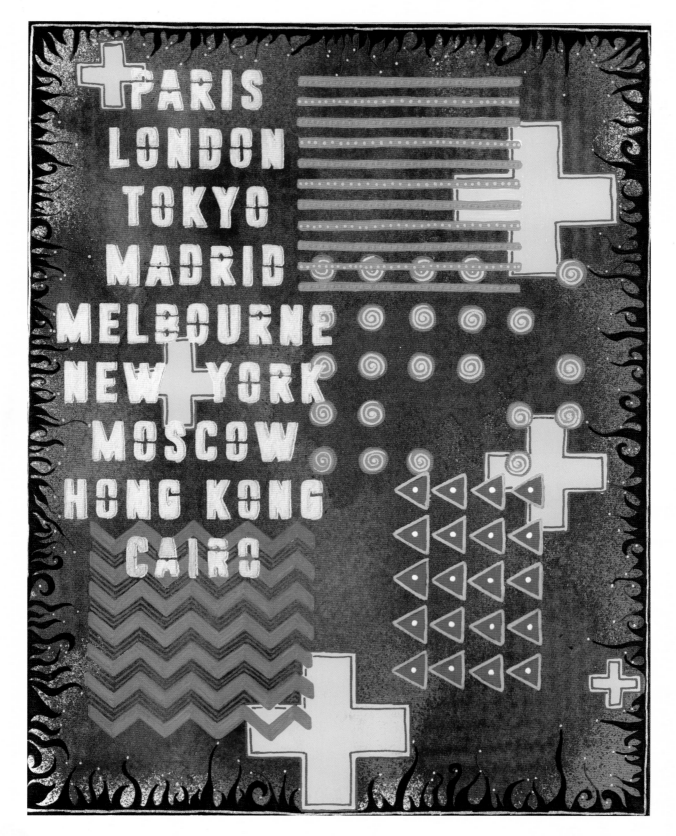

Remember how I suggested looking for stencils that have lots of images on them? This is a journal page that uses such stencils.
There are three different stencils on this page: the geometric shapes, the crosses and the place names. I used paint markers to get all
the shapes and words down. Later I went back with gel pens to add shadows, details and marks.

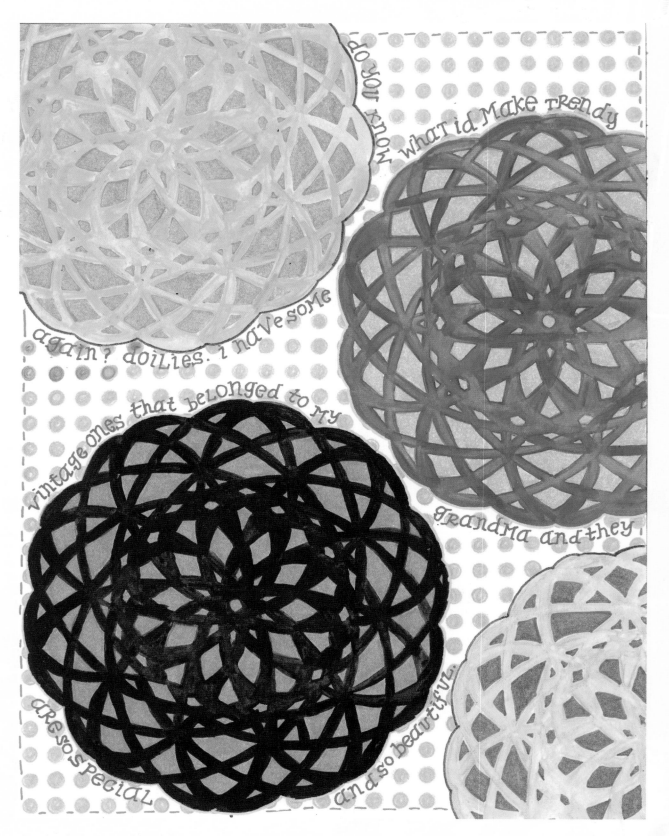

do you know what id make trendy again? doilies. i have some vintage ones that belonged to my grandma and they are so special and so beautiful.

I played with this image for a long time before committing any words to the page. I knew what I wanted to say but couldn't quite find the words. I used this great stencil from The Crafter's Workshop (it's called Geo Explosion), but all I saw was my grandmother's handmade doilies. I got the shapes down, used watercolor paint and Inktense pencils to put the color in, then let it sit for about two months while I contemplated. In this case, one stencil has been applied numerous times in various capacities to give the impression of several old table doilies.

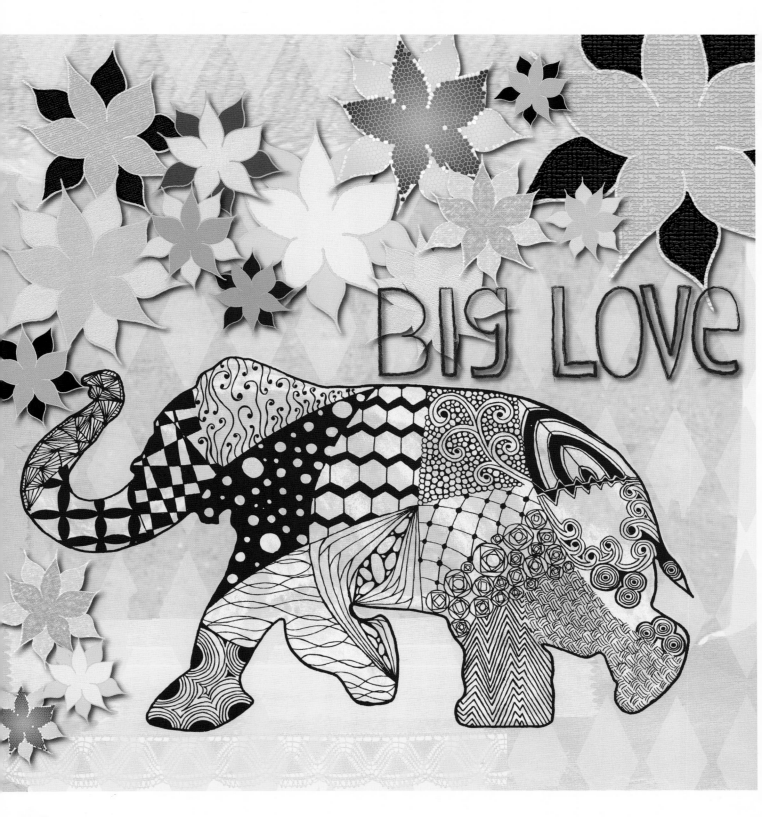

This is a digital artwork I created from hand-drawn elements. I started with Nathalie Kalbach's elephant stencil and filled it with tangles and patterns. I then drew the outline of the flowers. I scanned them in, as well as some collage elements I had (see the strip of lace there?) and got to work in Adobe Photoshop, changing colors, adding textures and changing the transparency of some of the images. I created this for the "Make Art That Sells" e-course, and it was easily the piece I had the most enthusiasm for.

and forget
not that the

earth delight
to feel your

barefeet and
the winds long

to play
with your hair.

Embracing Handwriting

Is there anything more inspiring than typography? There's something really special about artists who create art out of handwriting, those who create fonts and stylized writing that makes us swoon. You know what I'm talking about, don't you?

I'm not going to pretend it's effortless, but you can create your own stylized writing for your journals. There are many ways to do this, and more than a few books and websites written on the subject. I'm simply going to show you how I have developed my style. You can apply your own ideas to arrive at your own style.

This is a skill that takes time and practice to perfect. I have been writing in the margins of school diaries, notebooks and art journals since I learned to write. This isn't a new thing for me. However, after years of having students constantly ask about my writing in classes, I realized I could teach my style easily. The perfection comes from you and your willingness to work on it, to make it your own.

Handwriting changes—like so many other things in life. It is fluid and developing. Because of technology, I don't handwrite anywhere near as many things as I used to, and my handwriting bears the scars of that. I'm afraid I also break a lot of the rules we have about uppercases and lowercases, sizing and more. If I were at school, a pen license would be withheld, for sure. Don't let this stop you. Don't think you can't develop a great writing style of your own; you can. It just takes a little perseverance.

I am not the go-to authority on handwriting. I can only show you what I do. Some people tell me they love my handwriting, which is why I wanted to include this section in this book. But take it for what it is, just one of many approaches to typography, handwriting and lettering.

Most of us look at our own handwriting and cringe. Some people refuse to journal on their pages because of how they feel about their writing. But I can promise you that no one cares nearly as much about your handwriting as you do. Handwriting is personal. It's part of who you are, and we are not all stylized, beautiful works of art all of the time (well, I know I definitely am not!). Embrace your writing as part of what makes your pages distinctively YOURS.

Materials to Gather

paper, smooth to practice on
pens, your favorite fine liners
ruler

Attributes of Lettering

When I studied journalism at university, one thing I learned in my sub-editing class was about serifs and why they can be important. Serifs are the little marks on the ends of letter strokes.

For hand lettering, permanent pens like Pigma Microns or PITT artist pens are best, as they flow smoothly and dry quickly. I recommend using smooth paper—perhaps a thick cartridge or mixed-media paper. Watercolor paper and other porous papers sometimes cause pens to bleed, even when the pens are permanent.

abcdefg
hijkLM
NOPQRSt
UVWXYZ

Serif Fonts

Serif fonts (such as Times New Roman) are easier on the eye to read and are the type used almost exclusively for printed books and newspapers. There are no hard-and-fast rules when it comes to the use of serifs in the kind of stylized lettering we are talking about. Personally, I use them. It's the designer's eye (and much suppressed journalist) in me; I just like how letters look when they have serifs.

abc def g
hiJ kLM
nopqRSt
UVWXYZ

Sans Serif Fonts

Sans serif fonts (such as Helvetica and Arial) are fonts without those little marks. These are more often used in graphic design and to provide small bits of information such as the date and location of an event on a concert poster. Sans serif fonts may appear to be modern, but they date back to the very earliest times.

Practice Serifs

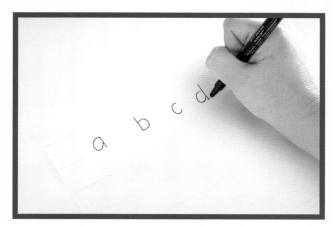

1 Draw Simple Letter Forms
In this photo, I've written the first four alphabet characters without serifs. This is how we teach our children to write their letters when they are little because such lettering is easy to identify.

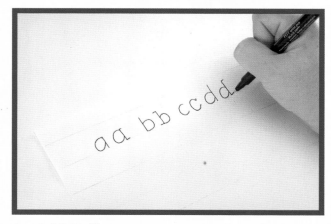

2 Add Serifs
I wrote the same letters again, this time with serifs. Seeing the differences side by side helps you to appreciate the difference.

Play with Uppercase and Lowercase

These two examples are finished, fully stylized exemplars of how I create my alphabets. See the following pages for ideas about size and shape.

ABCDEFG
HIJKLM
NOPQRST
UVWXYZ

abcdefg hijklm nopqrst uvwxyz

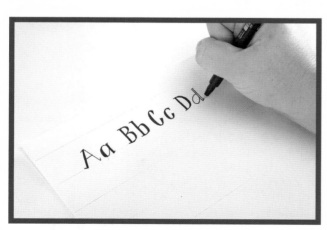

1 Create Two Versions of Each Letter
I recommend writing out each letter in uppercase and lowercase. Which do you prefer? Does one come more naturally than the other?

2 Try Mixing Cases
For me, a mix of both cases works. For example, I always use a lowercase *a*, always an uppercase *R*.

Try Out Font Sizing

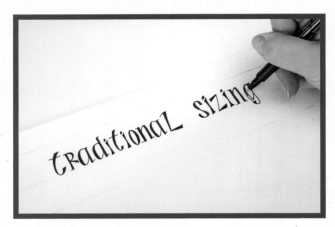

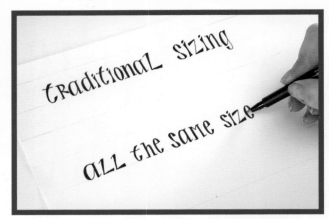

1 Observe Normal Ascenders and Descenders
When we are learning to write, we learn about how some letters are tall with ascenders (*b, d, h, l,* etc.) and some reach below the baseline with descenders (*f, g, j, p, q* and *y*). Let's turn that on its head!

2 Try Keeping Letters the Same Height
I create all my lettering to the same height—no extensions up or down. Everything fits within the same space. The example here shows how this impacts my letters. My *a* is the same height as my *h*. Because of this, some letters look smaller than we're used to seeing and some look bigger. However, I really like the effect.

Giving Letters Definition and Bringing it All Together

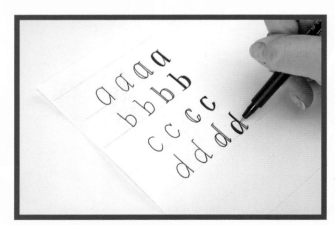

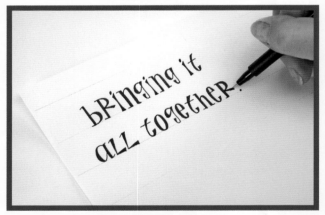

1 Add Thicker Strokes
Obviously when we use fine-line pens to create letters, they don't come out darker and thicker in certain spots, as the finished product shows. I create thicker "sides" to letters by adding another line and coloring in the spaces.

This example shows the full process: I create the letter, add the serifs (these give good indicators of where you want to add the thicker areas), then put the secondary lines in.

2 Combine All Techniques
So we've looked at adding serifs (or not). We've looked at uppercase letters, lowercase letters and the fun of mixing them up. We've looked at how we size the letters and where we add thickness for definition.

The trick is to bring ALL of those concepts together. The art on the following pages offers examples of combining these techniques.

abcdefg

hijklm

nopqrst

uvwxyz

This is an exemplar of how my alphabet looks—mixing the cases, keeping all the sizes consistent, serifs added and thicker sides. This has been years in development, and over time, the letters start to change a little. That's OK with me. How does your finished exemplar look? Creating a piece like this can be a useful reference as you're developing your style. It doesn't have to be perfect (my letters never are!), but it's a great way to practice and see what comes naturally. Give it a try!

though she be but little she is fierce.

SHAKESPEARE

My favorite Shakespeare quote—so much so, I have it tattooed across my back. I'm only 5'3" (160cm) so I'm almost always the shortest in the crowd (children aside), but you always know I am there!

it takes years as a woman to unlearn what you have been taught to be sorry for.

~ amy poehler ~

I really like Amy Poehler, and this quote from her deeply resonated with me. Even well into the twenty-first century, I continue to see women diminished and demonized for their success and strength. We've been conditioned to act a certain way, to accept certain things and to keep quiet when we don't like what is happening to us. It takes a certain maturity to learn that it shouldn't be that way and then years to learn how NOT to be that way.

the WORLd can be amazing when you're slightly strange.

You know, the most interesting people in life tend to be those who walk to their own beat. Often our first response is to recoil, but those people who are slightly strange—be it how they dress, what they say or how they choose to live their lives—are usually the ones who enrich us the most.

I think we should all try to get to know the strangeness inside ourselves; the results could be magical!

SOMe Of the MOSt WONDeRFUL PeOPLe aRe the ones who don't fit in boxes.

How true is this? I can think of some incredible people I've met along my life's journey who have completely defied what I thought they were or should be. It has taught me so much about myself and others, meeting these souls whom I had pegged as a particular type, only to find they were so much more.

Please note, I have never tried to actually fit a person in a box. I don't imagine it would be comfortable at all.

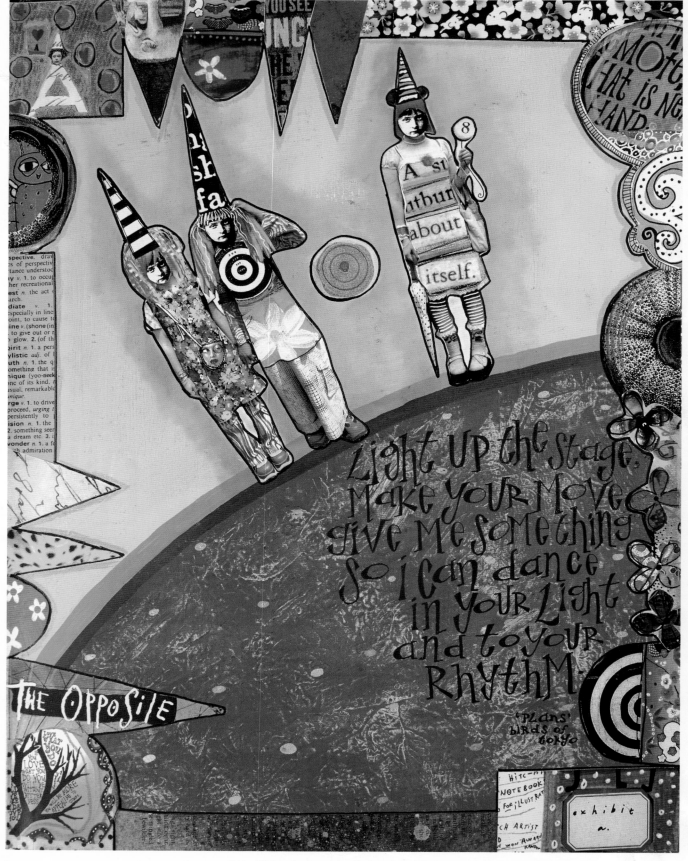

Materials used: collage elements, acrylic paint, paint markers, gel pens, pan pastels, Neo-Color II crayons.

Bird of Tokyo is a cool Aussie band and their song "Plans" was stuck in my head for months after its release. These lyrics really spoke to me, and when I created this page, they kept coming back to me as the right words for it. Song lyrics are a great alternative for your journal pages when you can't find the words to convey your own feelings.

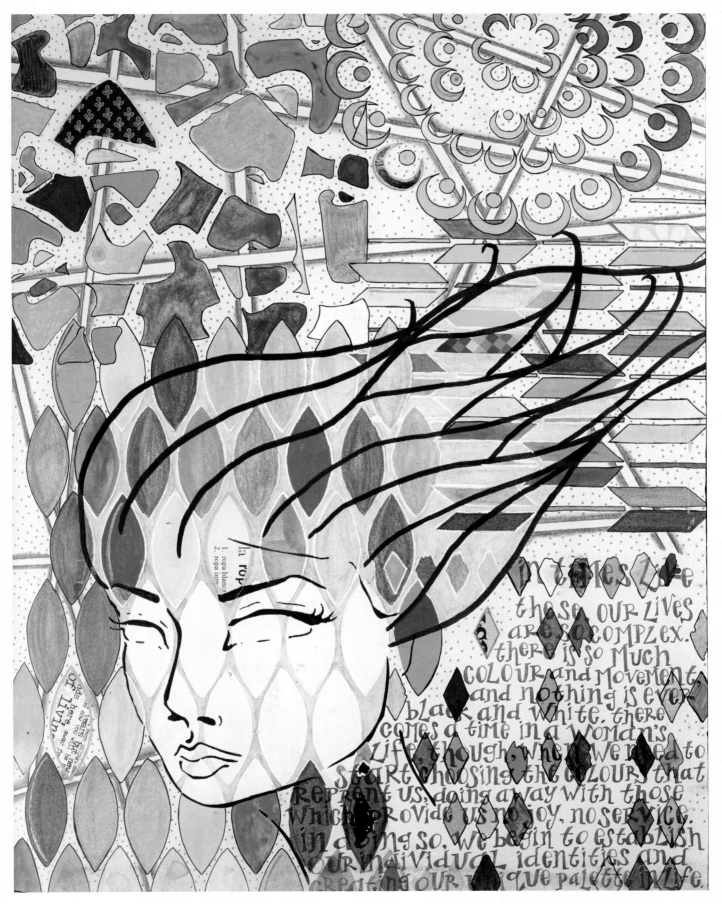

Materials used: watercolor paint, Inktense pencils, felt-tip pens, paint marker, graphite pencil, collage papers.

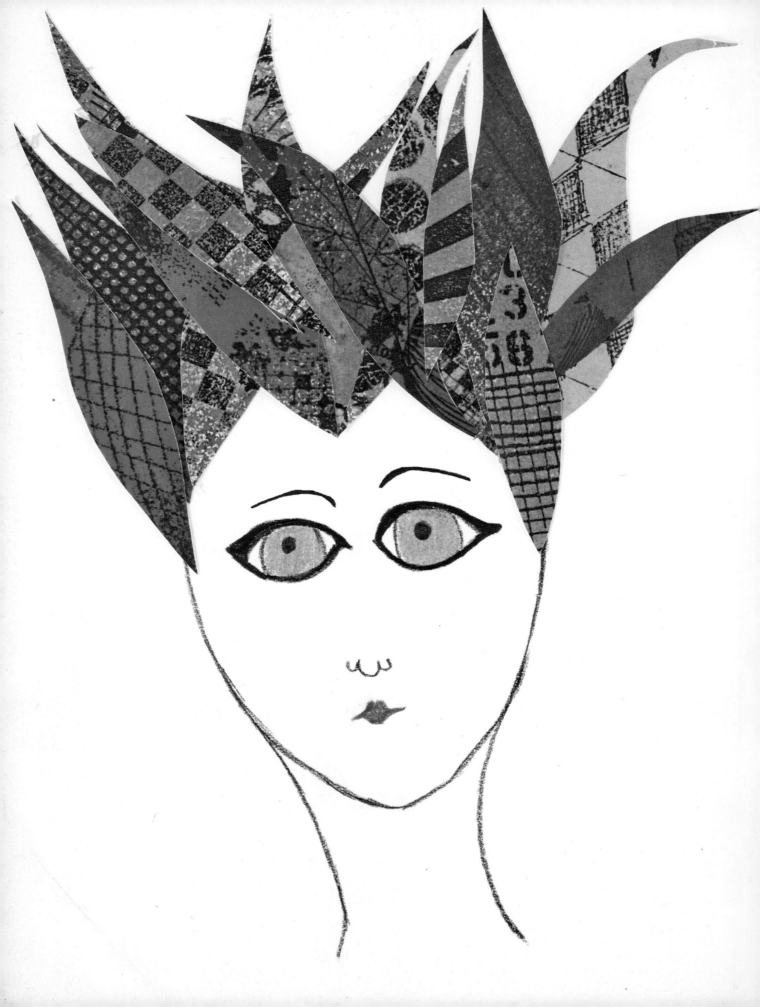

Creating Whimsical Faces

Drawing faces seems to be something we all like to be able to do in our journals, right? For me it is still very much a skill I am practicing and developing. I am lucky that my friend Jane Davenport is an expert in drawing faces, and that she taught me some invaluable basics. The problem for me is that I prefer faces that are not normal in shape and proportion. It must be the same for those who collect Blythe dolls—I like huge eyes, small noses and mouths. But that isn't really how the face looks, is it?

Why are faces even important to talk about? I wasn't sure if this was a topic I should cover in this book, given I know I'm not an expert on drawing faces. But the one thing I have tried to emphasize throughout this book is that journals are personal. Art journals are where we develop and practice our skills, where we create pages that reflect ourselves and our thoughts. And we are people, right? Why shouldn't we represent our physical selves, too?

The face is where we are our most unique selves. They say the eyes are the window to our souls. Can you express that without having eyes on your page?

In the following pages I'm going to give you some very basic instructions. I am not an expert on this, as I've said, but I can show you what I have learned and how I create faces in my journals. In the Resources section at the back of the book, there are details on books and websites that can help you develop your skills.

One thing I know is that drawing faces takes practice. Over time you will develop your own strategies to make the faces you create more your own.

Materials to Gather

acrylic paints of choice

collage sheets

colored pencils

eraser

graphite pencil

paint markers

Traditional Faces

The following instructions are what I learned from Jane. It's structurally correct and if you want realistic faces, these are the steps you'll need to follow, practice and refine. In the pages following, I provide some specific instructions relating to eyes, mouths, noses and hair. This is the structural part.

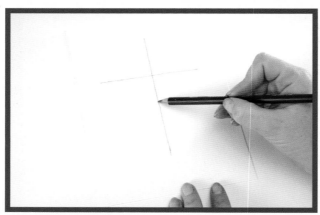

1 Start with a Cross
Draw a cross onto the paper, the approximate width and height you want your face to be.

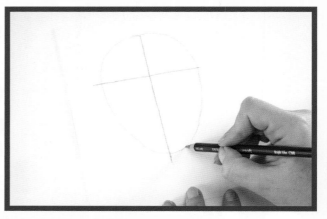

2 Draw an Oval
Use the cross to draw the general outline of the head in an oblong or oval shape.

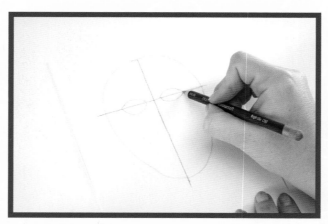

3 Add Eyes
Draw almond shapes for the eyes, using the horizontal line of the cross for placement.

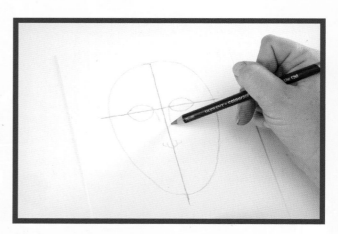

4 Draw a Nose
The bottom of the nose goes about halfway between the bottom of the eyes and the bottom of the chin. Draw a small ball with two smaller balls to reflect the nostrils and slightly curved lines running down from the inner corners of the eyes.

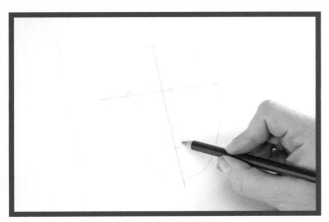

5 Draw the Mouth
This sits around halfway between the bottom of the nose and the bottom of the chin. The upper lip is much thinner than the lower lip.

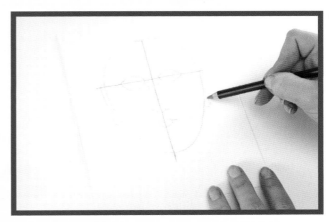

6 Add Ears
Draw the ears. These extend from the eye height to the mouth. (Yes your ears are that long!)

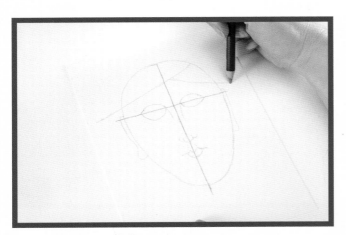

7 Create a Hairline
Draw the hairline. I've given our face here a side part because that's what I have!

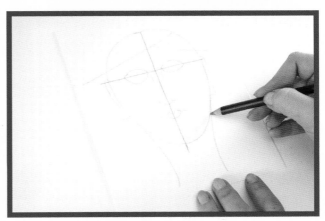

8 Determine Hair Length
If you want hair that drops down the face, choose a spot near the chin where it should reach to and draw a line inside the face to that point (and beyond if long hair is your desire). The line should start at the fringe area and drop down in a slightly outward direction, much the way hair falls naturally.

Whimsical Faces

This is the face style I use most of the time. Realistic faces are beautiful when done well, I just rarely do them well. Besides, I want my journals to reflect me, and I am not perfect. I want the faces that appear on my pages to have some of the whimsical nature I aspire to.

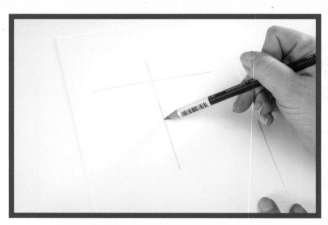

1 Begin with a Cross
As you did for the traditional face, begin by drawing a simple cross.

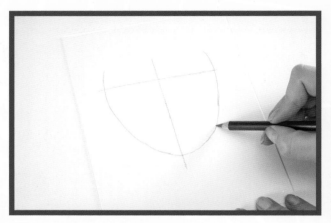

2 Outline the Head
Use the cross to draw the general outline of the face. My whimsical faces often have more pointed chins.

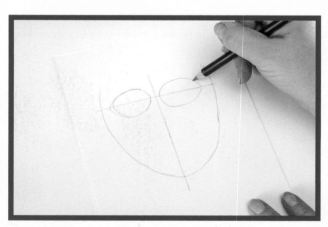

3 Add the Eyes
Draw the eyes using the horizontal line of the cross. You'll see I have drawn eyes that are closer together than those in the traditional example and that take up most of the width of the face.

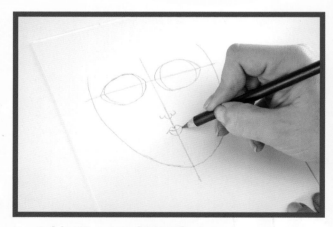

4 Add a Nose and Mouth
Draw the nose and mouth. I often draw tiny mouths on my faces.

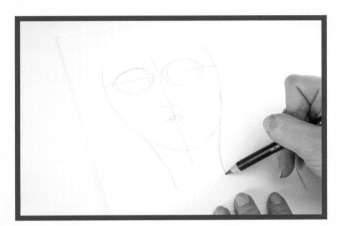

5 Add a Neck

Create lines for a neck that begin just a bit below where the mouth is.

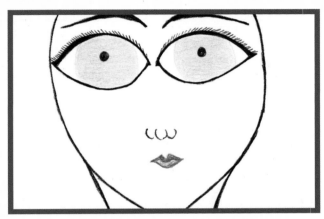

6 Add Details in Pen

Using colored pencil, add some color to the eyes and lips. Add pupils to the eyes as well. Outline and create final details with a black pen.

Draw the ears and hairline as desired. If you look closely, I often don't draw ears on my faces (and doesn't my psychiatrist have a theory about that!).

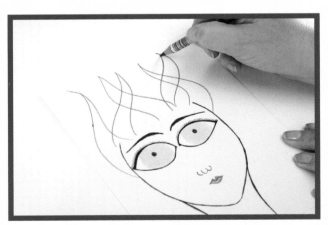

7 Add Lines for Hair

There are so many ways to add hair (and so many hairstyles to try) in your journals (a great place to audition styles before trying them out at the hairdresser!). One way is to draw the hair. I'm much better at hair that flows up rather than down (gravity need not be your concern). My influence here is the pop singer P!nk. (How does she keep her hair sticking up while she dances and sings?)

Draw the hair outlines, like upward flames.

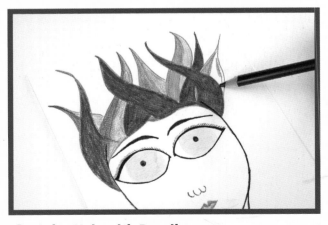

8 Color Hair with Pencils

Use colored pencil to color in the hair. Some parts should be darker than others to give the hair some dimension.

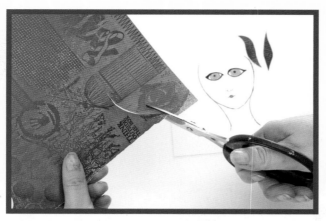

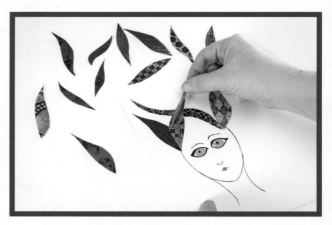

9 Try Cutting Paper Shapes for Hair
Alternatively you can grab some handmade collage sheets from chapter 1 and create hair from those. Cut out tendril-like shapes.

10 Adhere the Shapes to the Head
Once you have a variety, start sticking them down, layering them across each other. Use the longer ones first so they poke out above the smaller pieces you've cut.

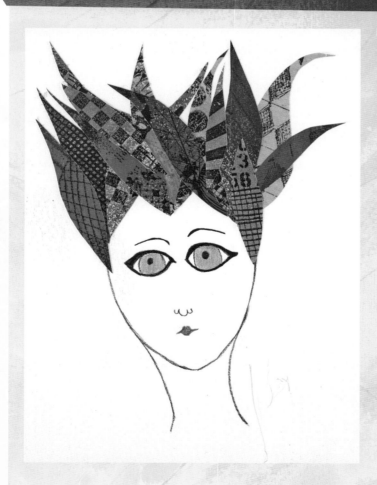

FACE BASICS TO KEEP IN MIND

The face is larger at the top than bottom—think of an upside down egg

Your eyes sit about halfway down your face—yes your forehead is that big, once you account for your hair.

Your eyes should be evenly spaced apart but not too far apart (or too close). Practice makes perfect, and using a pencil to start with will help you find the placement.

Remember, traditional style or whimsical—it's your choice. Your faces don't HAVE to be true to life. Have you thought about creating a cyclops?

It's nice to practice various skin tones and pigments. Think about whether you want diversity of skin colors in your journal, and be culturally sensitive if you plan on publishing your work online.

Play with different media. There are plenty of skin-toned paints, pencils and markers out there, but you need to allow for light falling on the face and the darkening and lightening of that. This also takes practice (and one I am still perfecting!).

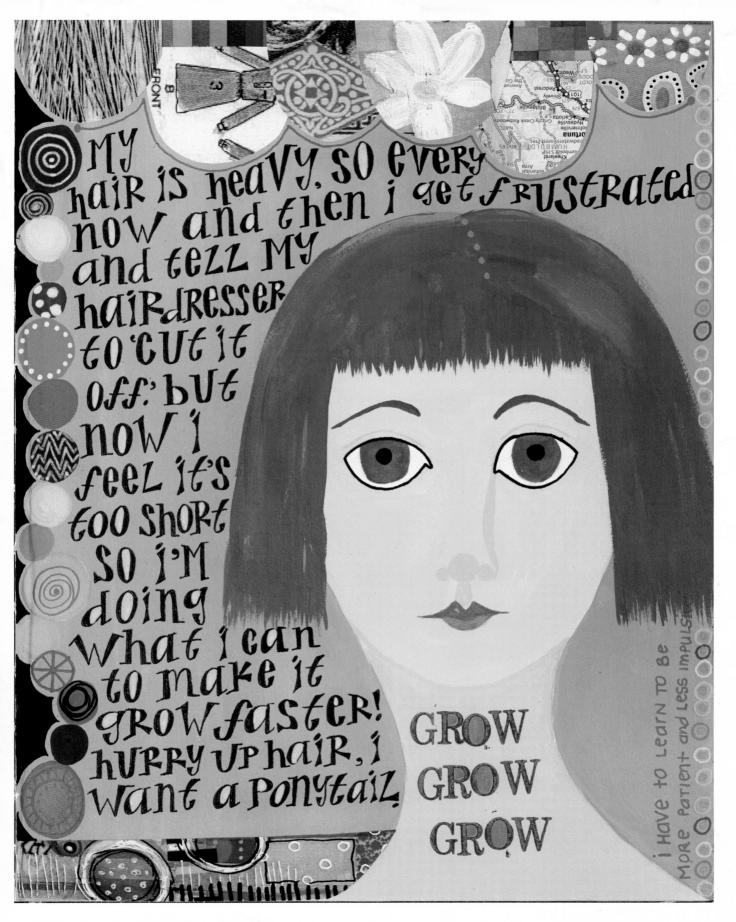

MY hair is heavy, so every now and then i get FRUSTRATED and tezz MY hairdresser to 'cut it off.' but now i feel it's too short so i'm doing what i can to make it GROW faster! hurry up hair, i want a ponytaiz.

GROW GROW GROW

i have to learn to be more patient and less impulsive.

This face is constructed using the traditional face process.

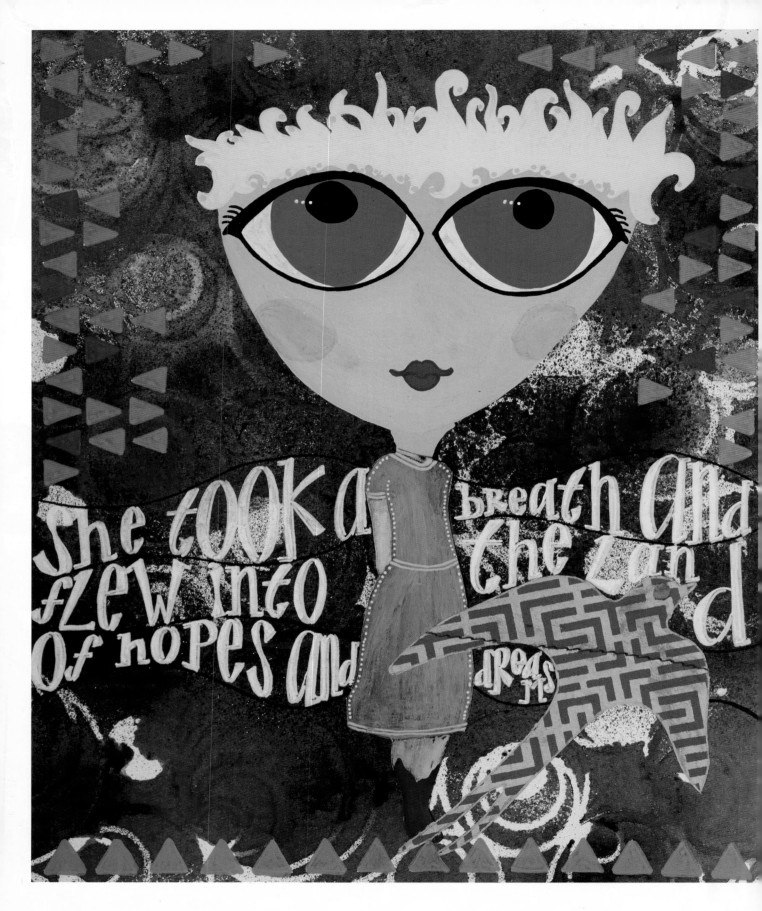

This is highly reflective of how my faces turn out in my journals. Eyes are the focal point (looking into the soul!).

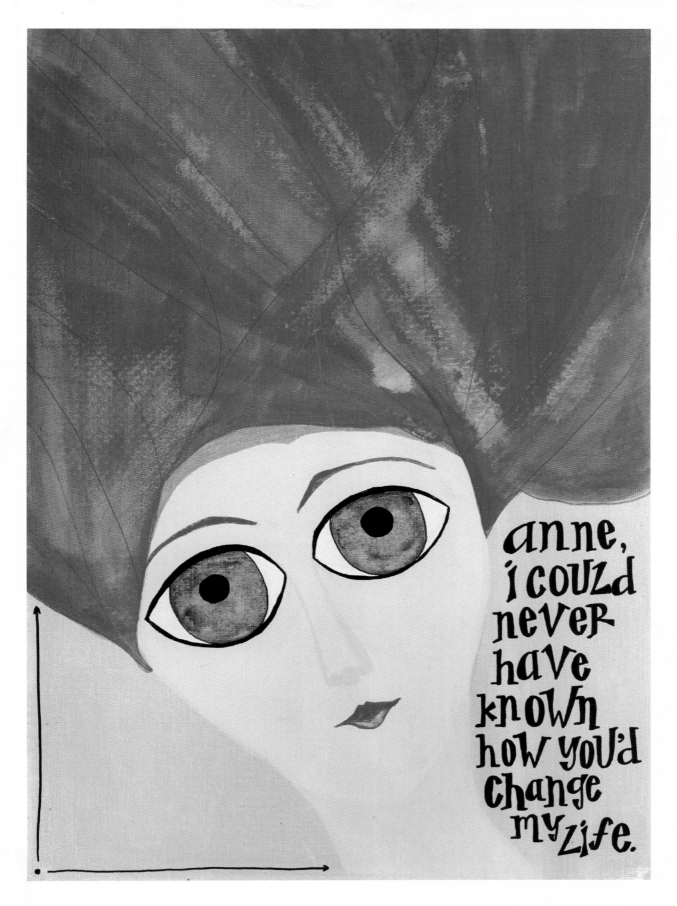

anne, i couzd never have known how you'd change my zife.

Anne of Green Gables was a book that literally changed my life. So many natural redheads have several tones of red in their hair, which I tried to re-create here with gouache, watercolor and pens.

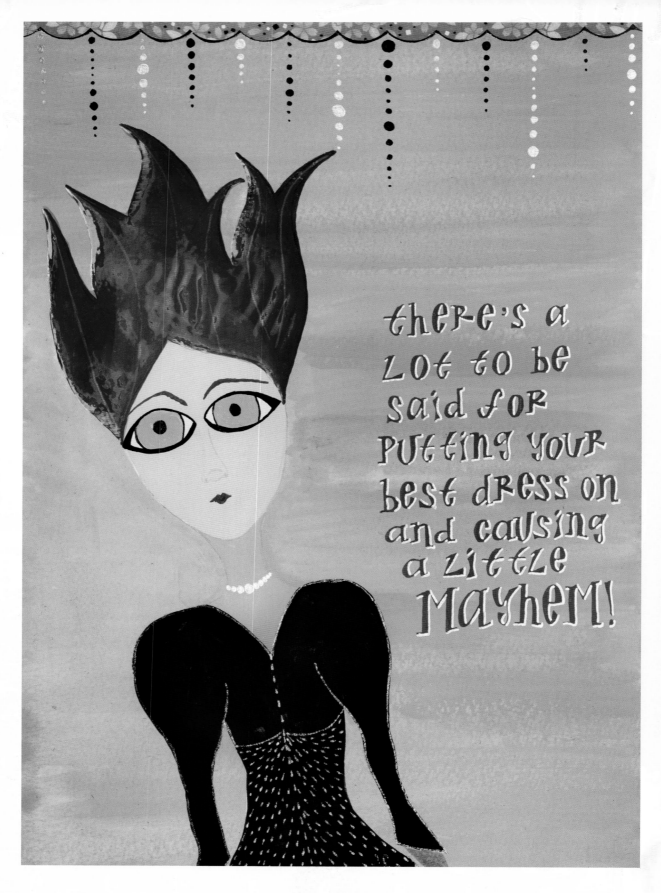

there's a lot to be said for putting your best dress on and causing a little MAYHEM!

I'm not sure if this lady started as Elsa from *Frozen* and went a little wild with the pink hair, or something else. You can see I love hair that flows up. If only I could get my hair to flow the same way (it would sure get some funny looks at the shopping mall!).

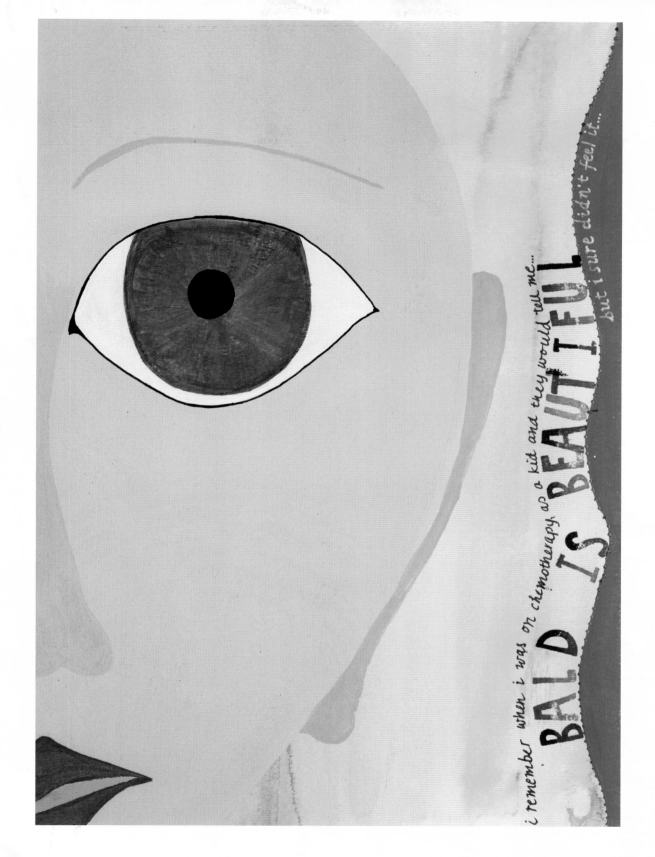

i remember when i was on chemotherapy as a kid and they would tell me... BALD IS BEAUTIFUL but i sure didn't feel it...

When I was a kid, I had chemotherapy and my hair fell out. For a new-to-puberty twelve-year-old girl, this was a disaster. I was often told "God made all heads bald then covered the ugly ones with hair." It was meant to make me feel better, but I wasn't convinced! My skull looks much better with hair. That said, I often see women rocking baldness these days (and I even feel a little envious I couldn't look so glamorous!).

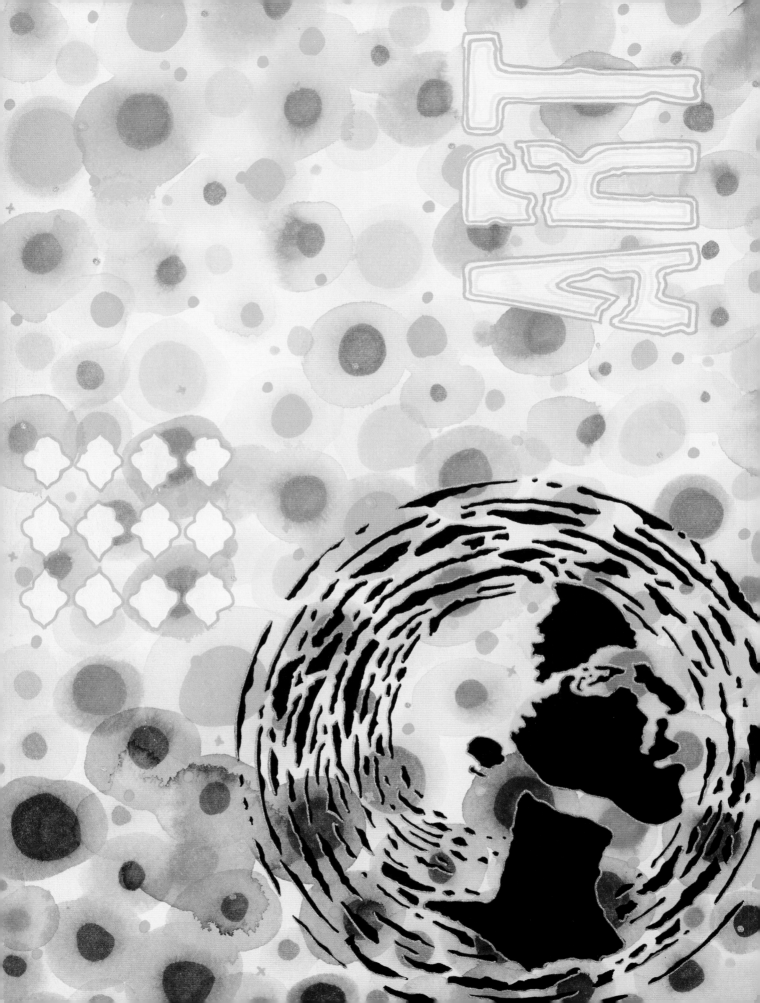

It's All in the Details

This is where all the hard work, techniques and theories come together, where we take everything we've learned so far and make it better. How, you ask? Well, we add *details,* some obvious, some subtle, but they are the details that make or break a journal page.

The following pages act as an inspirational gallery of art journal pages, with the left-hand side showing art without special details and the right-hand side including them. I invite you to study them carefully and to take note of the differences. I'm pretty sure that every time you'll prefer the page on the right, and that's the beauty of adding details to your journal work.

When I taught my class (under the same title as this chapter), the big *a-ha* moment for students occurred when they realized what was missing from their art journals—the stuff that would give their pages that "wow" factor. It's actually very easy to create that wow factorOften some gel pens are all you need.

Borders

Your pages don't have to have borders and I certainly don't always use them, but more often than not, I do, even if it's a simple pen line around the edge of the page. Why do borders make an art journal page feel more complete? It has to do with containing the images, I think, feeling like the page isn't spilling over, keeping the page within itself. I think a border also acts as a frame. Much as we frame art on our walls, we like frames on art in our journals.

Shadows

Adding shadows—be they subtle gray shadows or bright colored outlines—gives your page a feeling of dimension without actually adding texture to your page (I'll get to that in a moment). Shadows often cast from a particular direction and developing some consistency in that will help, but for now just look at the pages to follow and see where the shadows—both subtle and overt—are. Look at the pages on the left (without those details) and decide whether you think the shadows add something. I definitely think they do, but that is your decision. Gray markers such as Copic or Pitt brush pens are invaluable for this.

Black and white gel pens

Adding black and white pen marks will really lift your page. White marks draw the eye in. Black pens draw the colors around it to the eye. Each has a purpose. When used to add small, intricate details and lines, they can be a game changer.

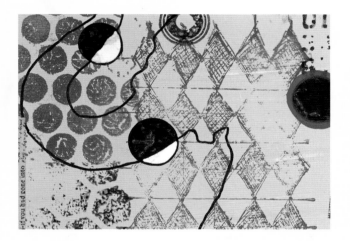

Adding stamps

We talked about using stamps to create collage sheets in chapter 1, but here we use stamps to add details to a journal page. When this page was first created, I decided to keep it black and white (and gray of course) with just a little bit of red. But it was lacking something, and I knew some stamps would be what was needed. However, instead of pulling out a red pen or marker, I thought I'd collage stamped images in red and black. The difference is clear, and what was an unexpected but pleasant surprise was how the stamping ink and the paint markers interacted with each other. Look closely: Some of those images look almost three dimensional. I couldn't have created that look without the stamps.

Texture

For those of you who like the tactile nature of art, you can use certain supplies to bring texture and dimension to your journal pages. You might like to use collage or handmade papers, or perhaps dimensional gloss products. Another great product for creating dimension is light modeling paste (I use Golden, but there are other brands); you can apply is right over your stencils (as I did) then lift your stencil to get the finished look. You can add paint to it (I used Payne's Grey paint mixed with the texture paste). I recommend leaving it overnight to fully dry and it's a great way of adding texture to your page without being so thick you can't get your journal closed.

Without a border

With a border

sometimes life gets a bit crazy and i wonder if i'll be ok...

then i think of us and know i'll be just fine.

Without dimension from shadows

With dimension from shadows

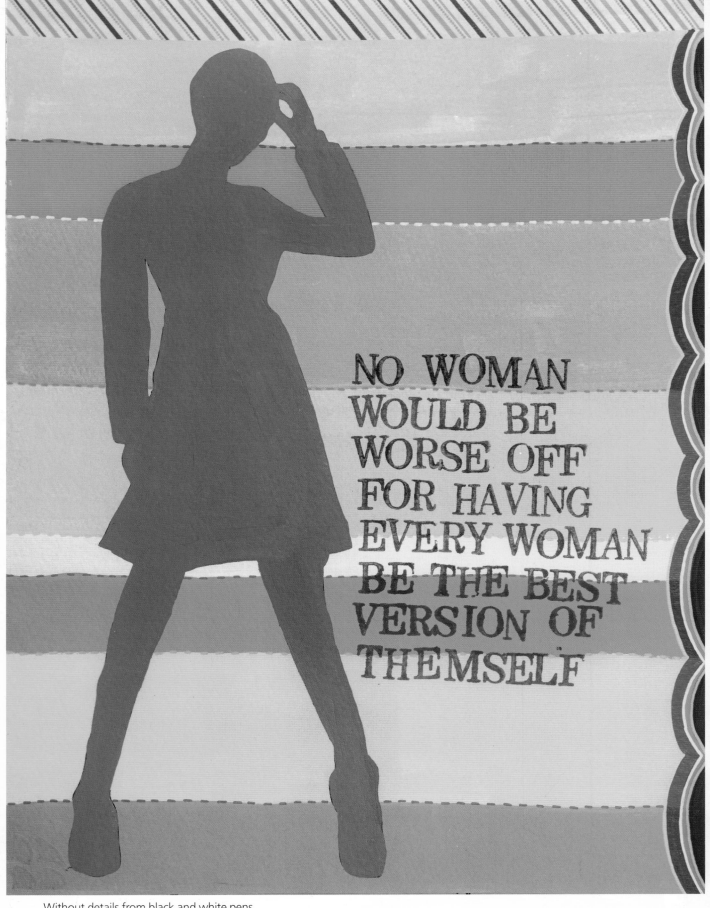

NO WOMAN WOULD BE WORSE OFF FOR HAVING EVERY WOMAN BE THE BEST VERSION OF THEMSELF

Without details from black and white pens

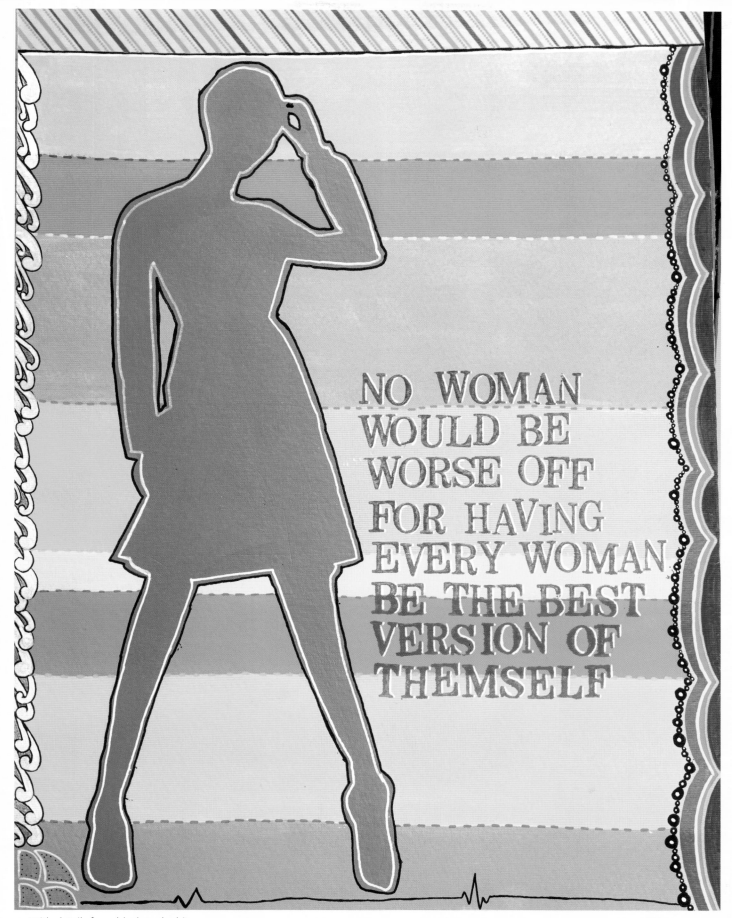

With details from black and white pens

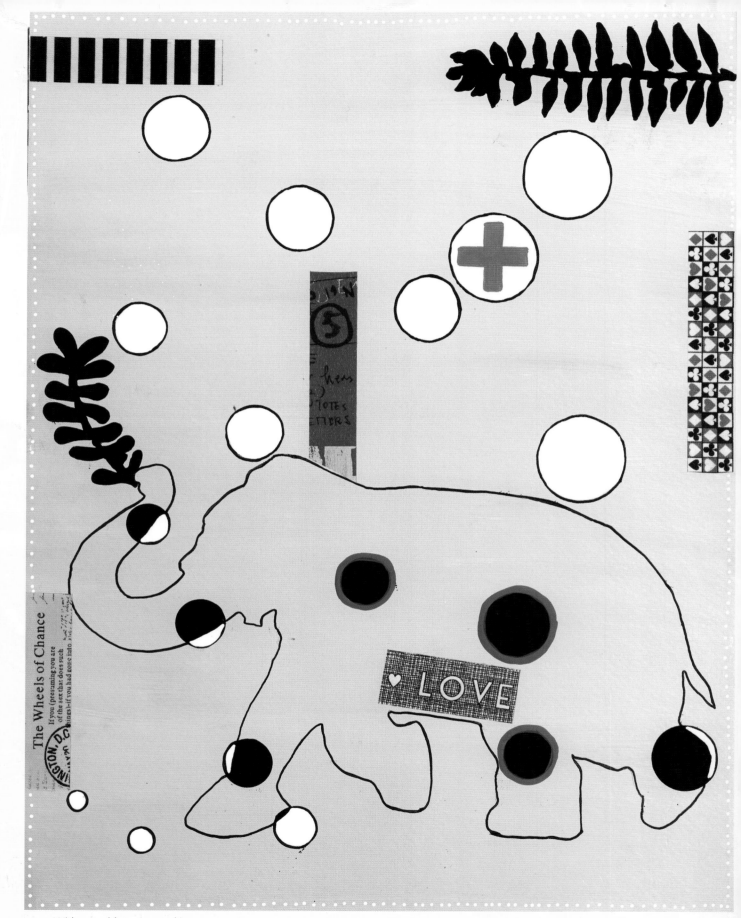

Without rubber-stamped imagery

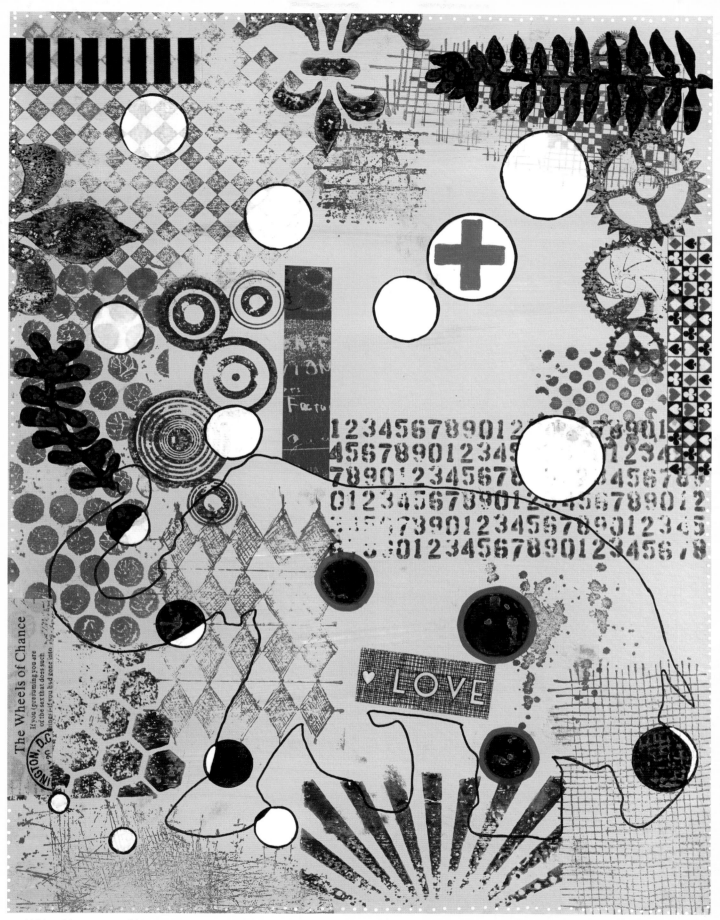

With rubber-stamped imagery

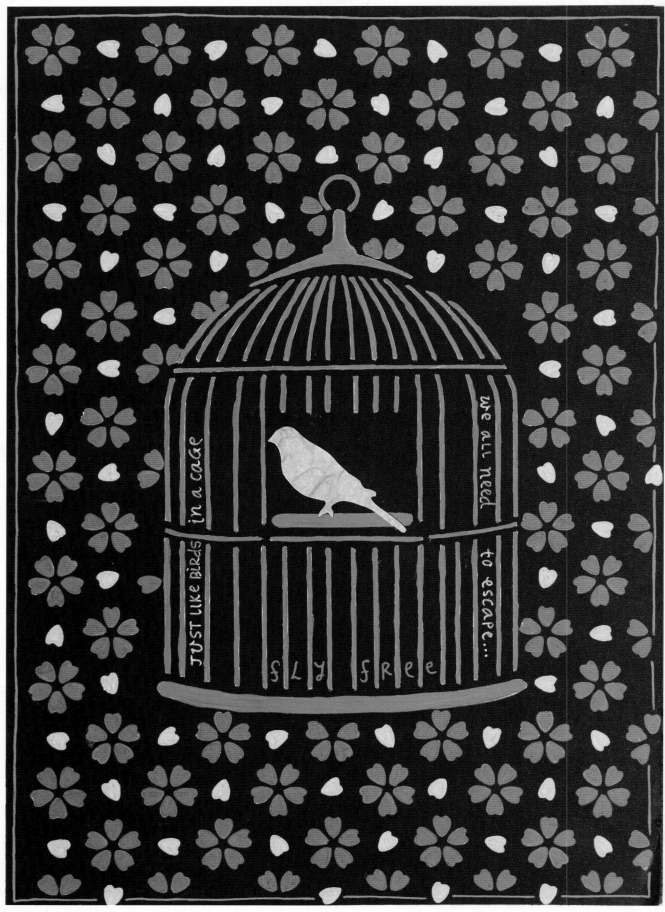

Without tactile texture

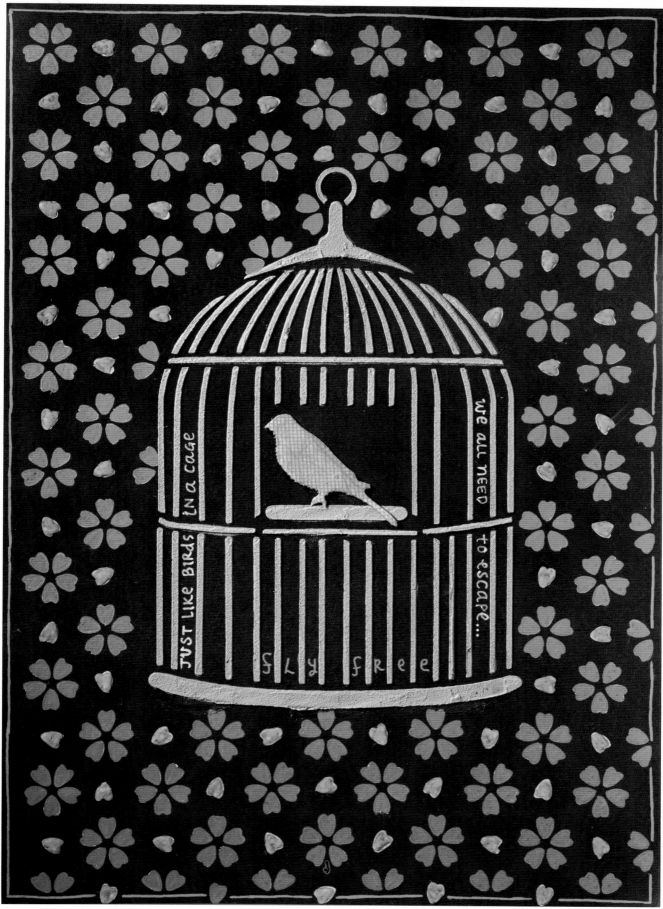

With tactile texture

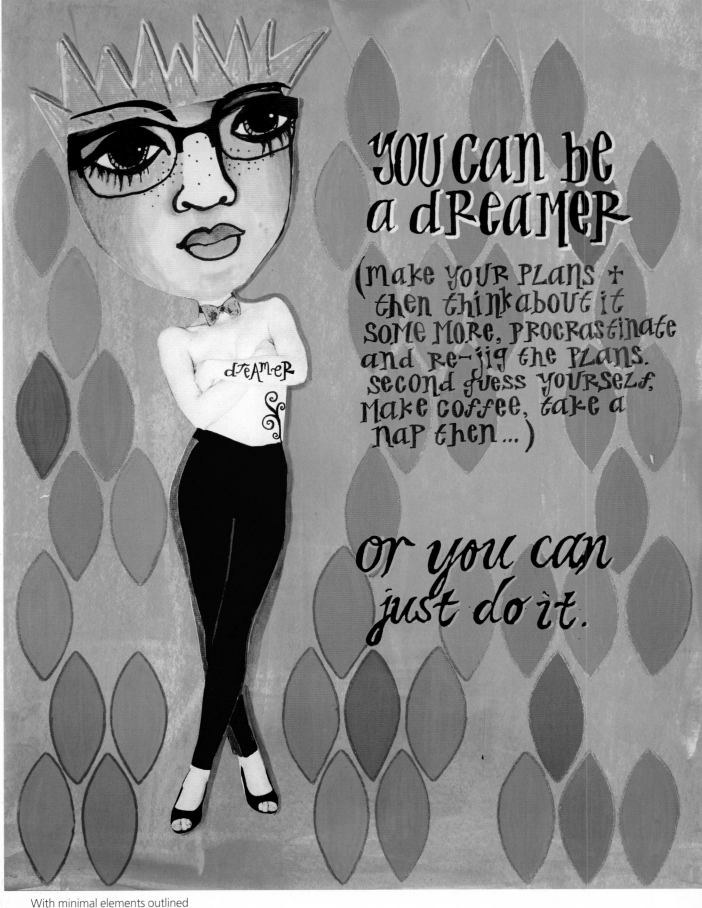

YOU CAN BE
A DREAMER

(MAKE YOUR PLANS +
THEN THINK ABOUT IT
SOME MORE, PROCRASTINATE
AND RE-JIG THE PLANS.
SECOND GUESS YOURSELF,
MAKE COFFEE, TAKE A
NAP THEN...)

or you can
just do it.

With minimal elements outlined

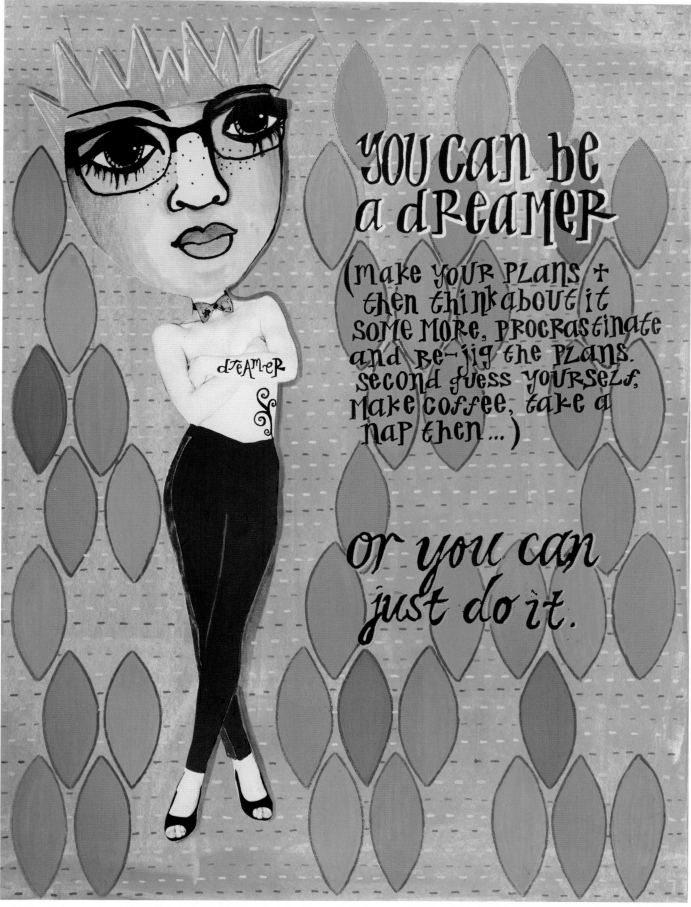

YOU CAN BE
A DREAMER

(MAKE YOUR PLANS +
THEN THINK ABOUT IT
SOME MORE, PROCRASTINATE
AND RE-JIG THE PLANS.
SECOND GUESS YOURSELF,
MAKE COFFEE, TAKE A
NAP THEN...)

or you can
just do it.

DREAMER

With maximum elements outlined, plus additional line detailing

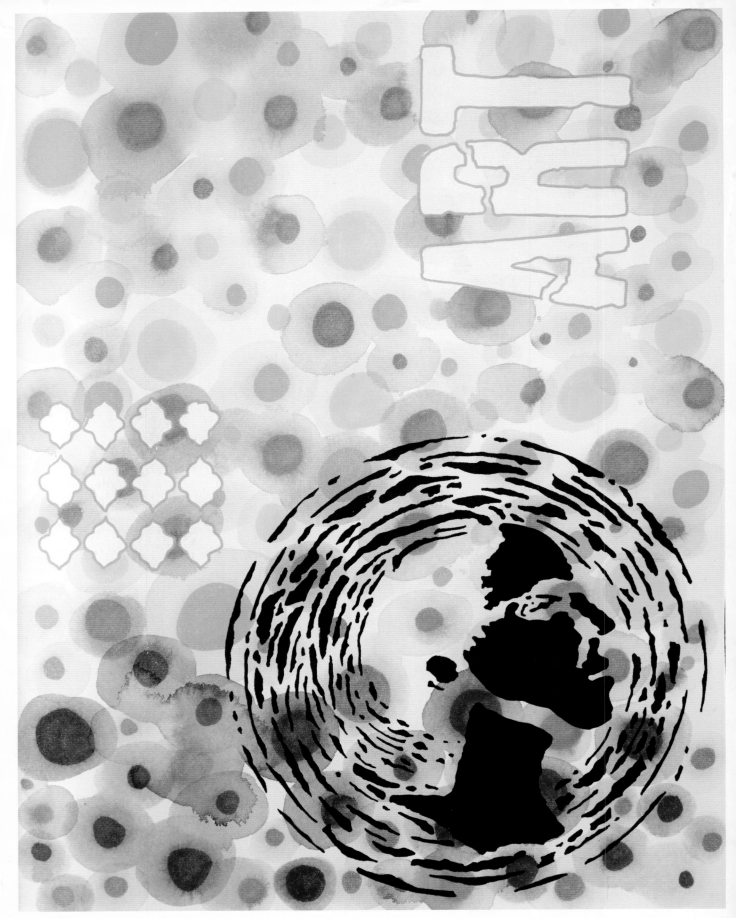

Without line details and spatter

With line details and spatter

Resources

I've provided lists here of art journaling and typography books as well as websites that I find inspiring. When you are short on ideas, these are all great places for inspiration!

Further Reading

Art Journal Courage: Fearless Mixed Media Techniques for Journaling Bravely
by Dina Wakley
North Light Books, 2014

Art Journal Freedom: How to Journal Creatively with Color & Composition
by Dina Wakley
North Light Books, 2013

Doodles Unleashed: Mixed-Media Techniques for Doodling, Mark-Making & Lettering
by Traci Bautista
North Light Books, 2012

Drawing and Painting Beautiful Faces: A Mixed-Media Portrait Workshop
by Jane Davenport
Quarry Books, 2015

Gelli Plate Printing: Mixed-Media Monoprinting Without a Press
by Joan Bess
North Light Books, 2014

Graphic Style Lab: Develop Your Own Style with 50 Hands-On Exercises
by Steven Heller
Rockport Publishers, 2015

Notan: The Dark-Light Principle of Design
by Dorr Bothwell and Marlys Mayfield
Dover Art Instruction, 1991

Printmaking Unleashed: More Than 50 Techniques for Expressive Mark Making
by Traci Bautista
North Light Books, 2014

The Sketchbook Project World Tour
by Steven Peterman and Sara Elands Peterman
Princeton Architectural Press, 2015

Typography Sketchbooks
by Steven Heller and Lita Talarico
Princeton Architectural Press, 2011

A World of Artist Journal Pages: 1000+ Artworks - 230 Artists - 30 Countries
by Dawn DeVries Sokol
Stewart, Tabori and Chang, 2015

Websites Worth Checking Out

Traci Bautista kollaj.typepad.com
Alisa Burke alisaburke.blogspot.com
Jane Davenport janedavenport.com
Dawn DeVries Sokol dawnsokol.com
Gelli Arts on YouTube youtube.com/user/GelliArts
Lisa Cheney Jorgensen lisacheneyjorgensen.blogspot.com
Liesel Lund liesellund.com
The Sketchbook Project sketchbookproject.com
Dina Wakley dinawakley.com
Michelle Ward michelleward.typepad.com

Index

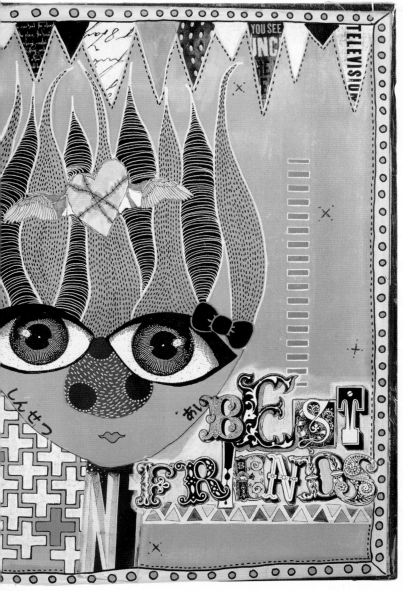

Other fine North Light Books are available from your favorite bookstore, art supply store or online supplier. Visit our website at fwcommunity.com.

20 19 18 17 16 5 4 3 2 1

DISTRIBUTED IN CANADA BY FRASER DIRECT

a content + ecommerce company

100 Armstrong Avenue
Georgetown, ON, Canada L7G 5S4
Tel: (905) 877-4411

DISTRIBUTED IN THE U.K. AND EUROPE
BY F&W MEDIA INTERNATIONAL LTD
Brunel House, Forde Close, Newton Abbot, TQ12 4PU, UK
Tel: (+44) 1626 323200, Fax: (+44) 1626 323319
Email: enquiries@fwmedia.com

DISTRIBUTED IN AUSTRALIA BY CAPRICORN LINK
P.O. Box 704, S. Windsor NSW, 2756 Australia
Tel: (02) 4560-1600; Fax: (02) 4577 5288
Email: books@capricornlink.com.au

ISBN 13: 978-1-4403-4279-0

Edited by Tonia Jenny
Designed by Geoff Raker
Photography by Christine Polomsky and Al Parrish
Production coordinated by Jennifer Bass

METRIC CONVERSION CHART

To convert	to	multiply by
Inches	Centimeters	2.54
Centimeters	Inches	0.4
Feet	Centimeters	30.5
Centimeters	Feet	0.03
Yards	Meters	0.9
Meters	Yards	1.1

About Kass

Kass Hall is an artist and writer from Melbourne, Australia. She teaches mixed-media classes around the globe, in between snuggles from her pugs, Elvis and Sunny. In her spare time, she is studying for her law degree. She is the author of *Zentangle® Untangled* and *The Zentangle® Untangled Workbook*.

Dedication

Dedicated to Jakob, Lukas and Millie; Addie and Macy; Laura, Olivia and Monique; Jeremy and Zoe, my beloved niblings. I'm so crazy proud of you all.

And to my dad, the best Starbucks date a girl could hope for!

Acknowledgments

This book would not have been completed without the contributions and support of the following people:

- My husband, Michael, and Elvis and Sunny
- Tonia Jenny, Brittany Van Snepson and the F+W team
- My dad, Bill Murphy
- Katie Bartrop, Natalie Playfair, Veronica Beasant and Ngaire Brown
- The staff and artists at River Studios, West Melbourne. It's a privilege to be part of your artistic community.
- Andrew and the team at Bluestone Coffee in New York City (We Melbournians take our coffee very seriously and having it made like we have at home, while on the other side of the world, trying to write a book, is a commodity more valuable than gold!).
- My team of medical professionals who make it their business not only to keep me alive, but thriving, despite the odds.

The author pays her respects to the Traditional Owners of the land on which much of the work for this book was created, in Melbourne, Australia.

Ideas. Instruction. Inspiration.

Receive FREE downloadable bonus materials when you sign up for our free newsletter at CreateMixedMedia.com.

Zentangle untangled

Inspiration and Prompts for Meditative Drawing

Kass Hall

Find the latest issues of *Cloth Paper Scissors* on newsstands, or visit shop.clothpaperscissors.com.

These and other fine North Light products are available at your favorite art & craft retailer, bookstore or online supplier. Visit our websites at artistsnetwork.com and artistsnetwork.tv.

Follow CreateMixedMedia.com for the latest news, free wallpapers, free demos and chances to win FREE BOOKS!

Get your art in print!

Visit **CreateMixedMedia.com** for up-to-date information on *Incite* and other North Light competitions.